THE BEST

Children's Portrait Photography

TECHNIQUES AND IMAGES FROM THE PROS

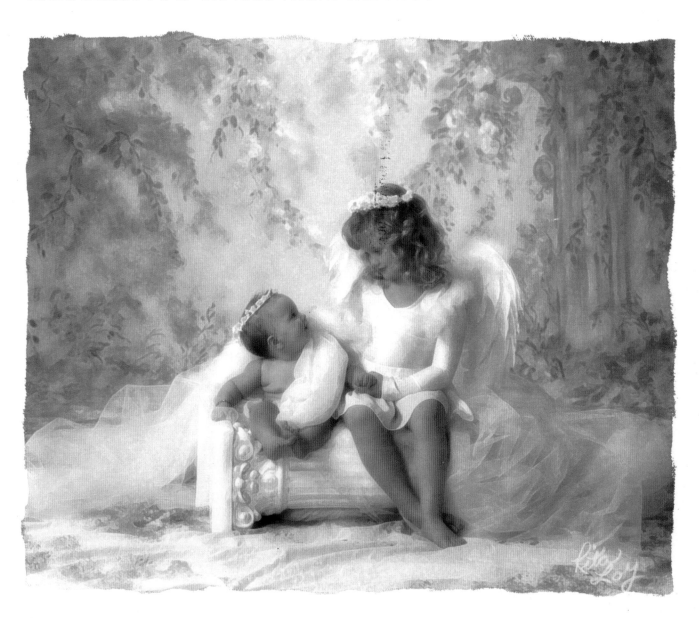

Bill Hurter

AMHERST MEDIA, INC. ■ BUFFALO, NY

Copyright © 2003 by Bill Hurter
All rights reserved.

Title page photo by Rita Loy.

Published by:
Amherst Media, Inc.
P.O. Box 586
Buffalo, N.Y. 14226
Fax: 716-874-4508
www.AmherstMedia.com

Publisher: Craig Alesse
Senior Editor/Production Manager: Michelle Perkins
Assistant Editor: Barbara A. Lynch-Johnt
Editorial Assistance: Grace Smokowski

ISBN: 1-58428-092-1
Library of Congress Card Catalog Number: 2002103405

Printed in Korea.
10 9 8 7 6 5 4 3 2 1

No part of this publication may be reproduced, stored, or transmitted in any form or by any means, electronic, mechanical, photocopied, recorded or otherwise, without prior written consent from the publisher.

Notice of Disclaimer: The information contained in this book is based on the author's experience and opinions. The author and publisher will not be held liable for the use or misuse of the information in this book.

Table of Contents

Introduction

Working with babies, small children and seniors can be the most exasperating profession on earth. Even if you do everything perfectly—beautiful posing and lighting, animated expressions, a wide selection of different images to choose from—the parents might say something like, "Wow, that just doesn't look like our little Travis." That's because little Travis doesn't look like their mental image of him anymore.

Parents have idealized mental images of their kids and when they see them in pictures, they sometimes don't emotionally relate to the child in the photograph. What they see in their minds' eye is their perfect child, not necessarily the same child who was just photographed.

That's just one pitfall in the world of children's portraiture. Kids, especially little ones, are easily frightened, so extra care must be taken to provide a safe, fun working environment. And the photographic experience must, in and of itself, be fun for the child. George Eastman, the great grandfather of the Eastman Kodak Company, once said that there are about 160 things that can go wrong in the taking of a picture. He wasn't talking about child's portraiture because there are easily double that number of things that can go wrong in the typical child's sitting.

But if children's portraiture were that impossible, then there wouldn't be so many children's photographers in the world. There are many rewards for excelling at this special skill. One successful children's photographer says that photographing children gives him an opportunity to be a kid himself, almost as if the process were an extension of his not yet being grown up. There is no doubt that the opportunity to enjoy the innocence of children—over and over again—is appealing.

Children's portraiture has also become highly specialized. Whereas many parents opt for having the kids photographed at the local department store, most discriminating customers realize that they don't get much for their money or efforts when they go that route. Many studios, while offering a variety of photographic services, such as fine portraits or weddings, also offer fine children's portraiture. Some photographers, like Tammy Loya, photograph only children. It has become her life's work and she is extremely good at it, treating each new client like a preferred customer.

While children's portraiture takes unending amounts of patience and skill, it also takes an extraordinary amount of timing and teamwork. If you pursue this specialty, you will eventually come to the conclusion that one pair of eyes and hands is not enough—that it takes a team to effectively photograph children. I recently visited the studio of Ira and Sandy Ellis, two award-winning Southern California photographers, on a day when they were photographing a six-month-old baby boy. With Sandy on the floor entertaining the infant, Ira was behind the Hasselblad, patiently waiting to get but a single frame here and there. The baby's mother was there and she was doing an amazing job at keeping the baby happy. Posed in a

Left: So, you think it's a piece of cake. Here are just a half dozen of the things that can go wrong in the creation of children's portraits. Photograph by Ira Ellis. **Above:** Customers will not be able to get this kind of portrait when they visit the local department store. This is a beautifully done portrait with a keen sense of design and style. Notice the expression and contact between the child and the camera/photographer. Photograph by Frances Litman.

giant clamshell, the baby, who could not yet sit up by himself, was plopped gently into position, his hair straightened, his chin wiped and then the entertainment started—Ira, Sandy and Mom all tried to get baby to look up and smile. I watched over Ira's shoulder and just as the baby looked at the camera and smiled, he also threw up—all over himself and the clamshell. And when Sandy picked up the baby, he threw up on Sandy too! The Ellises take moments like this in stride. Ira told me he was on frame eleven, "coming up on the frame-twelve meltdown." Every prop imaginable was on hand from a

squeaky bear to the bubble bottle to child-sized seashells (part of the set), which the little one loved.

As the session progressed, no pictures were being made. Baby would sometimes slide down in the shell or topple over and they'd have to start from scratch. At one point, Ira decided to try a change of pace and totally rearranged the set, turning the giant clamshell upside down, quickly adding some wedding veil material on top and promptly placed baby down on the upside-down shell on his tummy. By now Sandy was behind the camera and they were well beyond the frame-twelve melt-

Children's portraiture has evolved to the point that "fantasies" are the big thing. In this amazing image, photographers Ira and Sandy Ellis created a fantasy atmosphere with specialized props, hand-painted backdrops and intense use of Photoshop, a modern-day requisite for children's portraits. In this image, Ira added the pond and the ripples. Notice how the pond reflects each item at its edge.

down. As I watched, I saw baby start to raise his head and kick his feet and in a fraction of a second the moment was gone. And just at that fleeting instant, Sandy squeezed the shutter. Session over—amidst applause and hugs and general satisfaction over another good job.

Like many highly successful children's photographers, Sandy and Ira

Ellis are patient and thorough. The experience of watching them work brought home the insight that to be a successful children's portrait photographer, one must be part magician, part psychologist, part circus clown and part coach—and have the timing of a jewel thief.

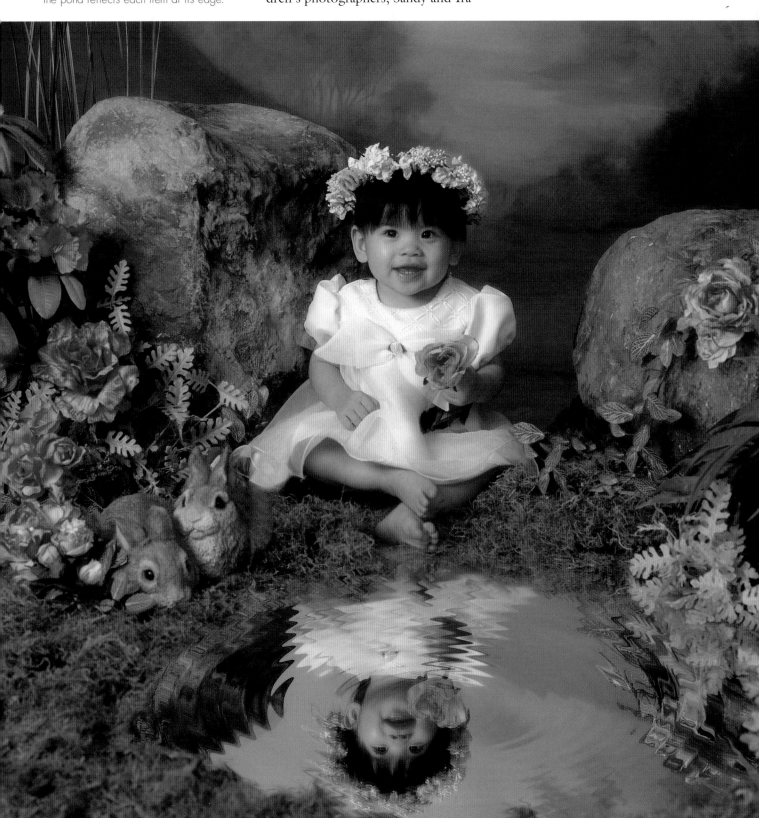

Camera Technique and Equipment

Most of today's finest children's portrait photographers use 35mm or medium format cameras. These formats have gradually replaced the large formats (4" x 5" and larger) in this field because of their ease of use and vast number of lenses and accessories. The inability to retouch these smaller negatives effectively has been negated by the ease and acceptance of

digital retouching. Another reason that these smaller film sizes have gained in popularity among professionals is the incredible improvements in film emulsions in the last twenty years. Films are sharper, with less apparent grain, better color fidelity and consistency, with vastly improved exposure latitude.

☐ LENSES

The Normal Lens. When making three-quarter–length or full-length portraits, it is advisable to use the normal focal-length lens (50mm on the 35mm format or 80mm on the 6cm x 6cm format, for example) for your camera. This lens will provide normal perspective when working at the distances required to make a three-quarter or full-length portrait. The only problem you may encounter is that the subject may not separate visually from the background with the normal lens. It is desirable to have the background

slightly out of focus so that the viewer's attention goes to the subject, rather than to the background. With a normal lens, depth of field is slightly pronounced, so that even when working at wide lens apertures, it may be difficult to separate subject from background. This is particular-

ly true when working outdoors, where patches of sunlight or other distracting background elements can easily draw your eye away from the subject.

The Short Telephoto. Good portraiture demands that you use a longer-than-normal lens to maintain

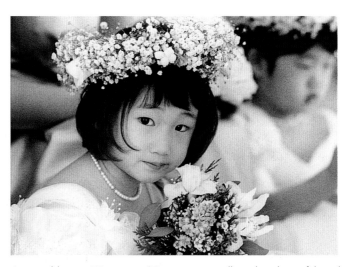

A normal lens, a 50mm on a 35mm camera, will produce beautiful results at the widest aperture, provided you do not get too close to your subject, distorting her features. Here, master wedding photographer, Phil Kramer, created this lovely portrait with a normal lens. With a longer focal length lens, the flower girl behind the subject would have been completely out of focus with no recognizable features.

accurate perspective of the human form. A normal focal length lens can distort the human form because in order to attain an adequate image size, the camera must be moved in too close to the subject, thus distorting the subject's features. This is particularly true in head-and-shoulders portraits, in which the nose can appear elongated, the chin will often jut out, and the back of the subject's head may appear smaller than normal. The short telephoto provides a greater working distance between camera and subject with no loss in image size, thus providing a more normal and desirable perspective.

The rule of thumb for selecting an adequate portrait lens is to choose one that is twice the diagonal of the film you are using. For instance, with the 35mm format, a 75 to 85mm lens is usually a good choice; for the 2¼" square format (6cm x 6cm), 100 to 120mm is fine, and for 2¼" x 2¾" cameras (6cm x 7cm), 110 to 135mm is advised.

TOP: The short telephoto is an ideal baby lens because it provides good image size with these tiny subjects. Here, expert baby photographer David Bentley uses a device—the blanket around the shoulders—that gets babies to prop themselves up. Notice the shallow depth of field and thin band of focus—also features of telephoto lens use. **BOTTOM:** A short telephoto lens is ideal for making head-and-shoulders portraits. Perspective is normal and the working distance from the subject is ideal. Background elements are softly muted if set to an eight to ten-foot working distance. South Carolina award-winning photographer Rita Loy made this delicate portrait. Notice the incredible highlights in the girl's hair—a primary element in the portrait.

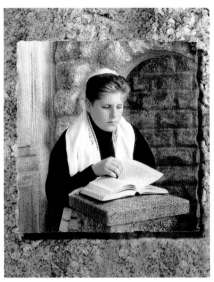

LEFT: Award-winning photographer Norman Phillips created this window-lit portrait with a longer telephoto. Notice how the plane of focus is just the frontal planes of the child's face and his hands. The background is completely blurred, thanks to working at a fairly wide lens aperture. **ABOVE:** In this portrait of their son, Ira and Sandy Ellis incorporate many of their posing props to create a beautiful Bar Mitzvah portrait. The image is given a textural feel in Photoshop and the primary image is brought into a template and positioned over a background layer of small stones. They have this image displayed in their spacious studio.

Longer Telephotos. You can use a much longer lens if you have the working room. A 200mm lens (for 35mm), for instance, is a beautiful portrait lens because it provides very shallow depth of field and allows the background to fall completely out of focus, providing a backdrop that won't distract from the subject. Such lenses also provide a very narrow angle of view. When used at large apertures, this focal length provides a very shallow band of focus that can be used to accentuate just the eyes, for instance, or just the frontal planes of the child's face.

However, you should avoid using extreme telephotos (longer than 300mm for 35mm) for several reasons. First, the perspective becomes distorted and features appear compressed. Depending on the working distance, the nose often looks pasted onto the child's face and the ears of the subject appear parallel to the eyes. Secondly, you must work far away from the child with such a lens, making communication next to impossible. You want to be close enough that you can converse normally with the child.

Many medium format photographers, particularly Hasselblad users, love to use the 250mm lens for portraiture. It throws backgrounds completely out of focus and is razor sharp, so the disparity between the out-of-focus background and tack-sharp subject produces a clean, crisp image. Those who use the 645 system (a hybrid system between 35mm and medium format) often consider the 150mm lens a favorite portrait lens. Both lenses blow out the background details, making the lens appear even sharper than it is.

□ **CAMERA STAND**

An accessory that is invaluable in the studio is the camera stand. If you're not familiar with this accessory, it is a floor-to-ceiling pole to which an adjustable camera stage is connected. The device is on wheels and with certain models, all you have to do is step down on the stand to make it free to roll. The camera can be raised and lowered from floor level to over six feet high in an instant. Like a fluid-head tripod, the camera can be positioned forward or back or laterally in one movement with the quick-release lever. In addition, adjacent to the camera platform is a basket or shelf in which you can place film, a meter, or toys and props to amuse small subjects.

□ **FOCUSING**

In a head-and-shoulders portrait it is important that the eyes and frontal planes of the face be tack sharp. When working at wide lens apertures

where depth of field is reduced, you must focus carefully to hold the eyes, ears and tip of the nose in focus. This is where a good knowledge of your lenses comes in handy. Some lenses will have the majority of their depth of field behind the point of focus; others will have the majority of their depth of field in front of the point of focus. You need to know how your different lenses focus. And it is important to check the depth of field

David Anthony Williams is a brilliant portrait and wedding photographer from Australia. In this charming portrait made at a wedding he used diffusion and very shallow depth of field to minimize the distracting background elements. In fact, he further diffused everything but the girl's face in Photoshop for a truly defocused look. The image almost looks as if he purposely front-focused so only the rear plane of focus caught the face.

with the lens stopped down to your taking aperture, using your camera's depth of field preview control.

Your main focal point should always be the eyes, which will also keep the lips (another frontal plane of the face) in focus. The eyes are the region of greatest contrast in the face, and thus make focusing simple, particularly for autofocus cameras, which need areas of contrast on which to focus.

When the subject is turned away from the camera so the eyes are not parallel to the film plane, you may have to split focus on the bridge of the nose to keep both eyes sharp—particularly at wide lens apertures.

Focusing three-quarter or full-length portraits is generally easier because you are farther from the subject, where depth of field is greater. Again, you should split your

focus halfway between the closest and farthest points that you want sharp in the image. And again, because of background problems, it is a good idea to work at wide lens apertures to keep your background soft.

□ **APERTURE**

Depth of Field. Short focal length lenses have greater depth of field than telephotos. This is why so much attention is paid to focusing telephotos accurately in portraiture. The closer you are to your subject, the less depth of field you will have. When you are shooting a tight face shot be sure that you have enough depth of field at your working aperture to hold the focus on the important planes of the face. Medium-format lenses have less inherent depth of field than 35mm lenses. A

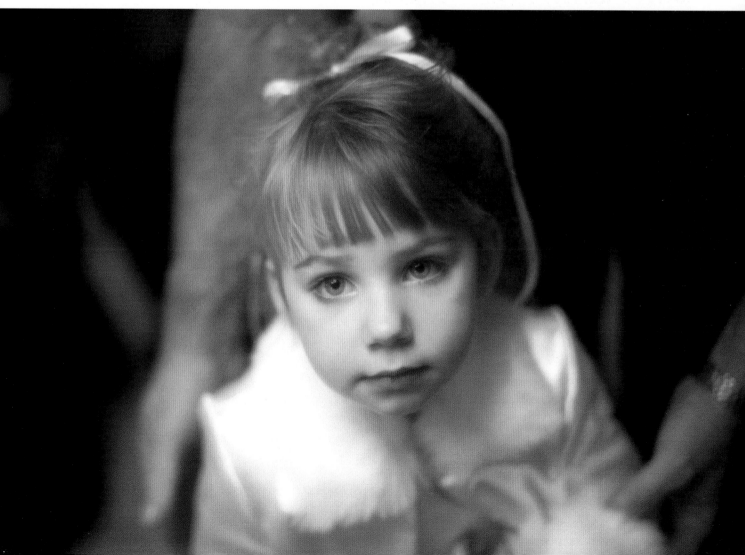

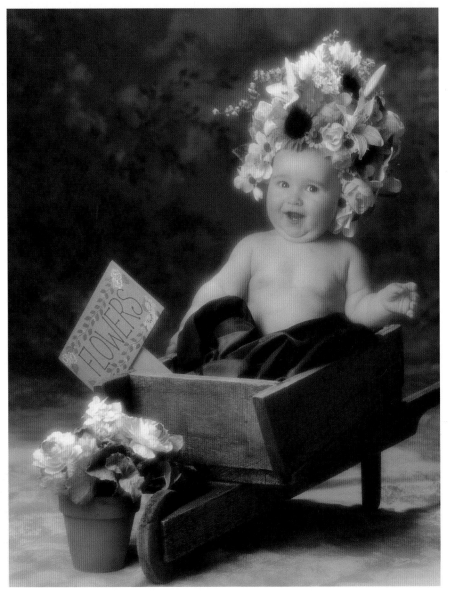

LEFT: You can increase depth of field by using a shorter focal length or by increasing the working distance between camera and subject. Here is Frances Litman's ridiculously cute portrait of a baby in a wheelbarrow, taken with a normal lens and a slightly increased working distance. Depth of field extends from the flower pot in the foreground to the top of the little one's "hat." **ABOVE:** Understanding depth of field is not only necessary for holding sharpness in critical parts of the image, it is also essential for keeping certain critical parts of the image unsharp. In this priceless baby portrait, David Bentley only wanted to hold the "toes to the nose." The curtains in the background, if sharp, would have detracted from the important parts of the portrait. Notice that David had the baby in the "tripod pose," which allows babies to sit up comfortably with a bit of stability.

50mm lens on a 35mm camera will yield more depth of field than an 80mm lens on a medium format camera, even if the lens apertures and subject distances are the same. This is important because many photographers feel that if they go to a larger format, they will improve the quality of their portraits. While the image will appear improved simply by the increase in film size, focusing and depth of field become much more critical with the larger format.

Learn to use your lenses' depth of field scale. The viewfinder screen often is too dim when the lens is stopped down to gauge depth of field accurately. So, learn how to read the scale quickly, and practice measuring distances mentally. Better yet, learn the individual characteristics of your lenses.

Shooting Apertures. Choosing the working lens aperture is traditionally a function of exposure level, but it is a matter of preference in many cases. For example, Norman Phillips prefers f/8 to f/11, even though f/11 affords quite a bit more depth of field than f/8. He prefers the relationship between the sharply focused subject and the background at f/8, saying that the subjects at f/11 look "chiseled out of stone."

Phillips is not alone. Many photographers have strong preferences for certain lens apertures. Some will shoot wide open, even though many lenses—even expensive ones—suffer from spherical aberration at their widest apertures. The wide-aperture preference arises from a desire to create a very delicate plane of focus in the portrait, making the point of focus the focal point of the composition. It is a stylistic approach that some clients don't like, but it has its supporters.

David Williams created this striking off-center portrait using a wide-open aperture so that everything beyond the subject's face is out of focus. He used a short telephoto to further blow out the background. If you look carefully at the massive catchlights in the eyes, you can see that they are created by skylight coming between two large pillars.

Other photographers, often traditionalists accustomed to the focus-holding swing and tilt movements of large format cameras, will opt for a small taking aperture that holds every plane of the subject in focus. This preference is most often seen in the studio, where background distance can be controlled, thus limiting the sharpness only to the subject.

It is said that a lens' optimum aperture—its sharpest aperture—is 1½ to 2 stops from wide open. Depth-of-field and lighting considerations often alter a basic strategy to shoot at a lens' optimum aperture.

There are those, too, who will shoot at the same aperture nearly every time. Why, when there is almost infinite variability to the lens aperture, would one choose the same aperture every time? Because these photographers know that aperture inside and out and can predict the final results—both the region of focus and depth of field—at almost any working distance. It is the predictability that they like.

□ **SHUTTER SPEEDS**
Your shutter speed must eliminate both camera and subject movement. If you are using available light and a tripod, $\frac{1}{30}$ to $\frac{1}{60}$ second should be adequate to stop average subject movement. If you are using electronic flash and a camera with a focal-plane shutter, you are locked into the X-sync speed your camera calls for. If you are using a lens-shutter, flash can be used with any shutter speed. With focal plane shutters, you can always use flash and a slower-than-X-sync shutter speed, a technique known as "dragging the shutter," meaning to work at a

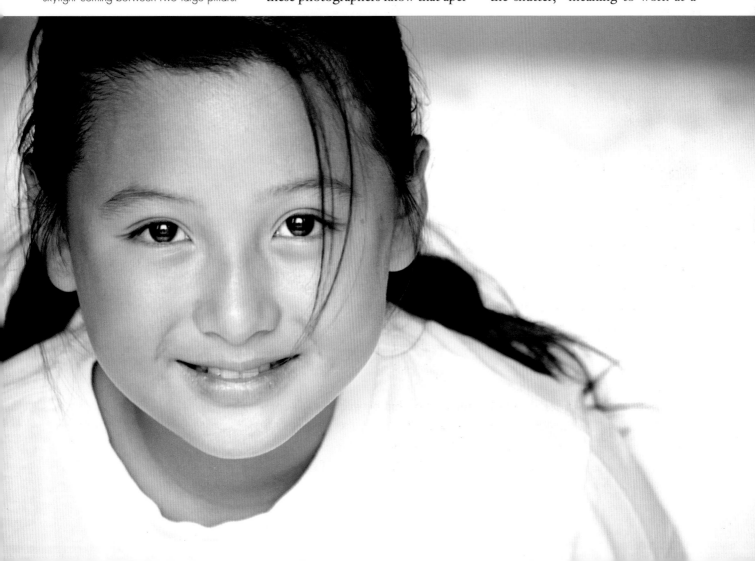

slower-than-flash-sync speed to bring up the level of the ambient light. This effectively creates a flash exposure that is balanced with the ambient-light exposure.

When working outdoors, you should generally choose a shutter speed faster than $\frac{1}{60}$ second because slight breezes will cause the hair to flutter, producing motion during the moment of exposure.

If you are handholding the camera, the general rule of thumb is to select a shutter speed setting that is the reciprocal of the focal length of the lens. For example, if using a 100mm lens, use $\frac{1}{100}$ second (or the next highest equivalent shutter speed, like $\frac{1}{125}$) under average conditions. If you are very close to the subject, as you might be when making a head-and-shoulders portrait, you will need to use a faster shutter speed (higher image magnification means you need to use a faster shutter speed). When farther away from the subject, you can revert to the reciprocal shutter speed.

When shooting moving children, use a faster shutter speed and a wider lens aperture. It's more important to freeze your subject's movement than it is to have great depth of field for this kind of photo. If you have any doubts about the right speed to use, always use the next fastest speed to ensure sharper images.

Bill McIntosh, a superb environmental portrait photographer, often chooses shutter speeds that are impossibly long. He works with strobe and often lights various parts of large rooms with multiple units. Some of the strobes may be way off in the distance, triggered by radio remotes synched to the shutter release. In order to balance the background strobes with the ambient light in the room and the subject light, he often has to reduce the light on the subject to incorporate all these other elements. Consequently, he ends up shooting at shutter speeds as long as $\frac{1}{4}$ or $\frac{1}{8}$ second. For the inexperienced, shooting portraits at these shutter speeds is an invitation to disaster, yet McIntosh routinely does it with incredible results.

LEFT: Michael Ayers created this portrait of his daughter Laura serving tea to her thirsty friend. Michael used umbrella strobe to light the interior. He also used image diffusion on the camera. He chose a short shutter speed to more closely match the outdoor exposure to the indoor exposure. For example, the outdoor exposure may have been $\frac{1}{500}$ at f/8. His indoor flash exposure, using a leaf-shutter camera, which has flash sync at any shutter speed, was adjusted to match the outdoor exposure within one f-stop. In this case, the exposure was $\frac{1}{500}$ at f/5.6, therefore balancing indoor and outdoor exposures on the same frame of film. **BELOW:** Norman Phillips created this handsome color-coordinated portrait of this young boy using a bounce flash exposure that was one stop less intense than the outdoor exposure.

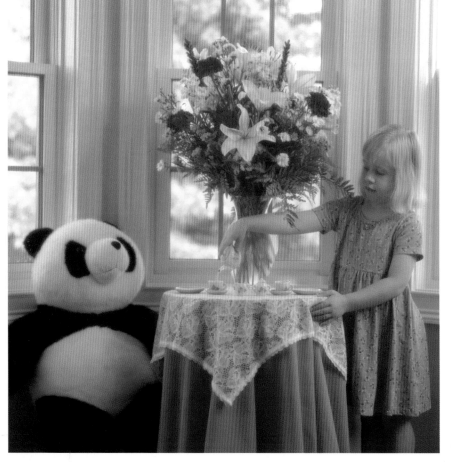

If you look closely at the grain structure of this lovely image, you will see that it is truly a pointillistic grain, much like the Impressionist masters used in their paintings. Master portrait photographer Robert Love created this image using very fast film, push processed to accentuate the grain. The very soft contrast is also reminiscent of the Impressionists.

Camera movement can occur even with the camera mounted on a tripod. The reason for this is that with SLR cameras, a mirror provides through-the-lens viewing. At the instant of exposure, that mirror must move out of the way and then quickly return to its 45-degree angle position in front of the film plane. This "mirror slap" causes vibrations within the camera. Some photographers, when working at slow shutter speeds, will lock the mirror in the up position, so that there is no mirror slap. Because there is no through-the-lens viewing with the mirror locked up, they will focus and compose the image first, then lock the mirror up and use a cable release to make the exposure. While most professional cameras are well protected against such vibration, mirror lockup can still be an adequate safeguard against camera movement in certain situations.

□ **FILM**

Extremely slow and extremely fast films should be avoided, generally, for most children's portraits. Black & white and color films in the ISO 25 range tend to be too contrasty for producing the delicate tonal range necessary in children's portraits, and exposure latitude is almost nonexistent with these films. With slow, contrasty films, you tend to lose delicate shadow and subtle highlight detail if exposure is even slightly off.

Ultrafast films in the ISO 1000 range offer an ability to shoot in near darkness but produce a larger-than-normal grain pattern and lower-than-normal contrast. Many photographers use these films in color and black & white for special painterly effects in children's images. Robert Love, an outdoor portrait specialist, uses primarily ultrafast films to exploit their graininess and

Today's color negative films feature incredible sharpness, low grain and extensive exposure latitude. This beautiful portrait, made by Ira and Sandy Ellis, was created using available light on Kodak's Portra 160 NC (normal color) film.

create an Impressionist feeling in his images. His award-winning children's portraits often highlight large expanses of open area and a very small subject in order to further enhance the illusion of a painting.

Black & white films in the ISO 1600 to 3200 range, like Kodak TMZ-3200, produce the same type of low contrast and high grain structure and are ideal available light films. Since the grain structure is "tight" in these particular films, they accept enlargement well.

Today's color negative films in the ISO 100–400 range have amaz-

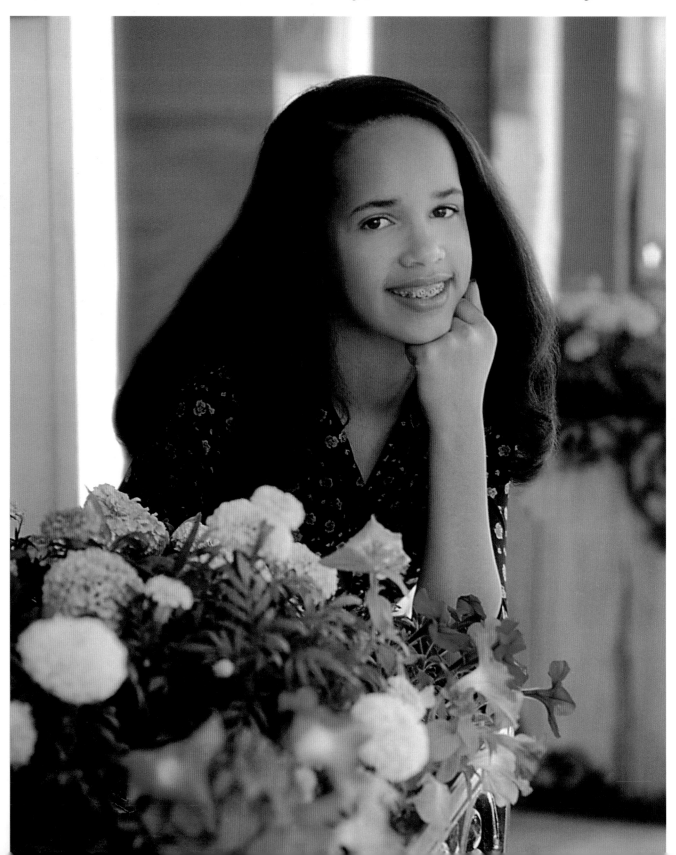

ing grain structure compared to films of only a few years ago. They often possess impressive exposure latitude, which can range from two stops under to three stops over normal exposure. Of course, optimum exposure is still (and will always be) recommended, but these new films are extremely forgiving.

The two major film companies, Kodak and Fuji, offer "families" of color negative film. Within these families are different speeds, from ISO 160 to 800, for example, and either varying contrasts or color saturations. Kodak's Portra films include speeds from ISO 160 to 800 and are available in NC (natural color) or VC (vivid color) versions. Kodak even offers an ISO 100 tungsten-balanced Portra film. Fujicolor Portrait films, available in a similar range of speeds, offer similar skin-tone rendition among the different films as well as good performance under mixed lighting conditions. Most photographers will settle on a family of films they like and can predict and use all of the different emulsions for different situations. It also helps if scanning negatives from the same film family, since the scanner settings are identical.

□ **EXPOSURE**

Exposure and Metering. Film companies are notorious for overrating the film speed of their products. For that reason, most pros are skeptical and will automatically underrate their film to produce slightly more exposure in the shadows. Many professionals expose their 400 speed film at E.I. 320 and their 800 speed film at E.I. 640. This is true for both color and black & white films.

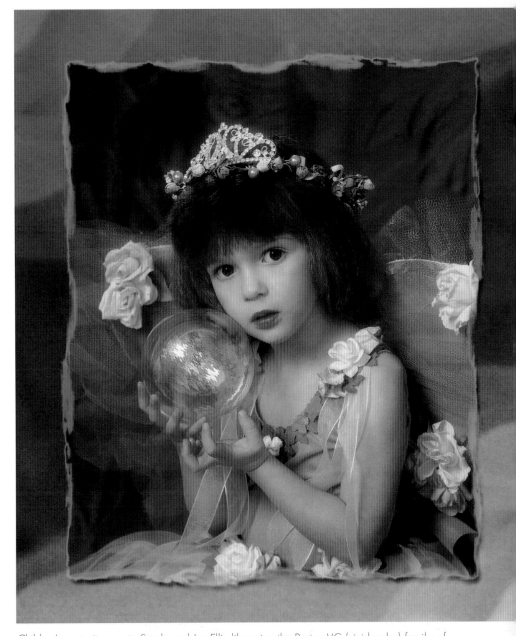

Children's portrait experts Sandy and Ira Ellis like using the Portra VC (vivid color) family of films for their children's fantasy portraits. These films produce exceptional skin tones, scan easily and have tremendous sharpness and latitude.

Because exposure is critical for producing fine portraits, it is essential to meter the scene properly. Using an in-camera light meter may not always provide consistent and accurate results. Even with sophisticated multi-zone in-camera reflectance meters, brightness patterns will influence the all-important skin tones. The problem arises from the meter's function, which is to average all of the brightness values that it sees to produce a generally acceptable exposure. Essentially, the in-camera meter wants to turn everything it sees into 18-percent gray, which is dark even for well suntanned or dark-skinned people. If using the in-camera meter, take a meter reading from an 18-percent gray card held in front of the subject. The card should be large enough

to fill most of the frame. If using a handheld reflected-light meter, do the same thing—take a reading from an 18-percent gray card or a surface that approximates 18-percent reflectance.

The preferred type of meter for all types of portraiture is the handheld incident light meter. This meter does not measure the reflectance of the subjects, but measures the amount of light falling on the scene. In use, stand where you want your subjects to be, point the hemisphere (dome) of the meter directly at the camera lens and take a reading. This type of meter yields extremely consistent results, because it measures the light falling on the subjects rather than the light reflected from the subjects. It is less likely to be influenced by highly reflective or light-absorbing surfaces.

One caution with using handheld incident meters: If metering a back-lit scene, in which direct light is falling on the subject, shield the meter's dome from the backlight. The backlight will influence the exposure reading and your priority should be the frontal planes of the face.

The ultimate meter is the hand-held incident flashmeter, which also reads ambient light. There are a number of models available, but they all allow you to meter both the ambient light at the subject and the flash output, again, at the subject position. The problem is that you either need to have an assistant trip the strobe for you while you hold the meter, or have the subject hold the meter while you trip the strobe to get a reading. You can also attach a PC cord to the meter and trigger

the strobe that way, but PC cords can be problematic, particularly when there are children running around.

One solution is to fire the strobe remotely with a wireless triggering device. These devices use transmitters and receivers to send signals to and from the flash or flashes that are part of the system. There are several types of wireless triggering devices. Optical slaves work with bursts of light, such as that from a single electronic flash. The other lights, equipped with optical receivers, sense the pulse of flash light and fire at literally the same time. Radio slaves send radio signals in either analog or digital form. Digital systems can be used almost anywhere and they aren't adversely affected by local radio transmissions. For a completely wireless setup you can use a separate wireless transmitter for the handheld camera meter. This allows you the ultimate freedom in cordless metering, since you can meter the ambient and flash exposures from the camera position without the need of an assistant or PC cord. The unit wirelessly fires the flash (or multiple flashes) in a similar manner to the transmitter on the camera.

In order to minimize the number of cords traversing the set—a danger not only to small children but harried photographers—many photographers will opt for the wireless triggering of all their studio lights.

Spotmetering. A good spotmeter is a luxury for most photographers. It is an invaluable tool, especially if you are working outdoors. The value of a spot meter is that you can use it to compare exposure values within the scene, something you can't do as

The reason that perfect exposure is so important is because it optimizes the film's and paper's response, making them capable of producing amazing detail in either end of the tonal curve. In this lovely high-key portrait by David Bentley, notice the detail in the white curtains and dress and the subtle gradations of white throughout. The antique white chair possesses specular (pure white) highlights in the midst of flat white highlights—an amazing feat of exposure.

critically with an incident meter. For example, you can look at the highlights in your subject's hair, which may be illuminated by sunlight and compare that reading to the exposure on the subject's face, which may be illuminated by a reflector. If the hair is more than two stops brighter than your exposure you will have to adjust one or the other to maintain good detail in both areas. Similarly, in the studio, you can use the spotmeter to check on the values created by various lights, being able to read them individually or collectively.

While the spotmeter won't be called on frequently, those times when you need it may make the difference between a great shot and a reshoot.

Studio Lighting

K ids are photographed just as often in the studio as they are outdoors and in the home. The basic lighting setups you will use should be simplified for active subjects and short attention spans. Elaborate lighting setups that call for precise placement of backlights, for example, should be avoided in favor of a single broad backlight that creates an even effect over a

wider area. In fact, when photographing children's portraits, if one light will suffice, don't complicate the session. Simplify!

□ THREE DIMENSIONS AND ROUNDNESS

A photograph is only a two-dimensional representation of a three-dimensional subject. It is an illusion. Lighting is the primary tool by which to enhance the perception of three dimensions. Put another way, your goal in lighting for portraiture

This delicate portrait of brother and sister is successful because of its simplistic lighting and elegant posing. A beauty light in a parabolic reflector was used as a main light at about 60 degrees off the camera/subject axis. A moderate fill light was bounced off the ceiling, and hair and background lights were used at reduced power to open up the rest of the image. Image made by noted portrait artist Robert Lino.

is to show roundness and three-dimensional form in the human face.

The human face consists of a series of planes, very few of which are completely flat. The face is sculpted and round. It is the job of a portrait photographer to show the contours of the face. This is done primarily with highlights and shadows. Highlights are areas that are illuminated by a light source; shadows are areas that are not. The interplay of highlight and shadow creates roundness and shows form. Just as a sculptor molds clay to create the illusion of depth, so light models the shape of the face to give it depth and form.

□ **LIGHT POSITIONS AND FUNCTIONS**

Key Light and Fill Light. The two main lights used in portraiture are called the key light and the fill light. The key and fill lights should be high intensity lights fitted with either reflectors or diffusers. Polished pan reflectors (also called parabolic reflectors) are silver-coated "pans" that attach to the light housing and reflect the maximum amount of light outward in a focused manner. Most photographers don't use parabolic reflectors anymore, opting for diffused key and fill-light sources. These diffusion light sources use small reflectors within the umbrella or softbox to focus the light onto the outermost translucent surfaces of the diffusion device. If using diffusion, the entire light assembly should be supported on sturdy light stands or boom arms.

The key light, if undiffused, should have barn doors. These are black, adjustable metal flaps that can be opened or closed to control the width of the beam of the light. Barn doors ensure that you light only the parts of the portrait you want illuminated. They also keep stray light off the camera lens, which can cause image-degrading flare.

The fill light, if in a reflector, should have its own diffuser, which is nothing more than a piece of frosted plastic, acetate or cloth mesh in a screen that mounts over the reflector. The fill light should also have barn doors attached. If using a diffused light source (such as an umbrella or softbox) for a fill light, be sure that you do not "spill" light into unwanted areas of the scene, such as the background or onto the taking lens. All lights, whether in reflectors of diffusers, should be "feathered" by aiming the core of the light slightly away from the subject, employing the more dynamic edge of the beam of light.

Hair Light. The hair light is a small, undiffused light. Usually it takes a scaled-down reflector with barn doors for control and a reduced power setting (because hair lights are almost always used undiffused). Barn doors are a necessity, since this light is placed behind the subject to illuminate the hair; without barn doors, the light is likely to strike the lens surface, causing flare.

Background Light. The background light is also a low-output light. It is used to illuminate the background so that the subject and

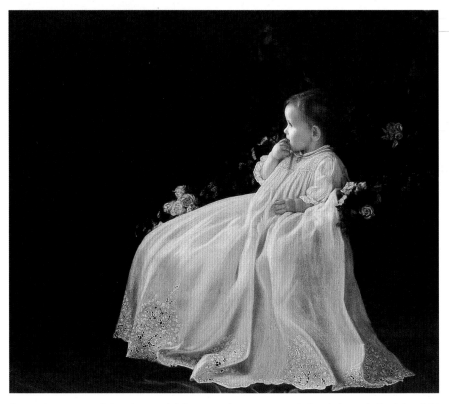

Tammy Loya created this elegant child's portrait by using a single key light set behind the child and a modest fill light that created detail in the flowing christening dress. The fill light was gelled yellow to provide a firelight glow to the portrait. The dress was retouched with pencil strokes to give it a textural feeling and to bring out the intricate lacework. The overall feeling of this beautiful portrait is that it is a painting. Roses and other garlands of flowers hide the large chair that is supporting the child.

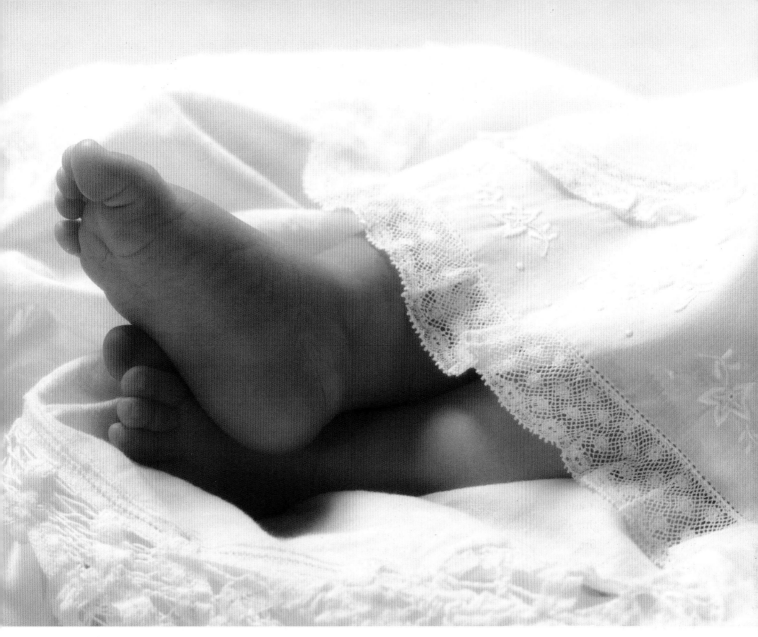

background will separate tonally. The background light is usually used on a small stand placed directly behind the subject. It can also be placed on a boom arm and directed onto the background from either side of the set.

Kicker. Kickers are optional lights used similarly to hair lights. These add highlights to the sides of the face or body to increase the feeling of depth and richness in a portrait.

Kickers are used behind the subject and produce highlights with great brilliance because the light just glances off the skin or clothing.

Since they are set behind the subject, barn doors should be used.

Kickers and hair lights, because they produce relatively narrow beams of light, require that your subject hold fairly still once posed. Otherwise, these lights either miss their target or they end up poorly lighting the subject.

If a backlight is needed, either for tonal separation from the background or to illuminate the hair, use a diffused backlight source at low intensity. An umbrella, placed off to the side and behind the subject, works well, but watch out for flare!

The key light in this delightful portrait is really the backlight. It is essentially like lighting a profile—the backlight defines the outer shape of the feet and the fill light merely fills in the shadows created by the key light. If you look carefully, you can see delicate highlights and beautiful roundness on each of the tiny toes. Photograph by Rita Loy.

Umbrellas and Softboxes. Umbrellas and softboxes are ideal on-location or in-studio lighting solutions for children's portraits. A single softbox will produce beautiful soft-edged light, ideal for illuminating little faces. Umbrellas, including the shoot-through type, can be used similarly and are a lot easier to take on location.

Photographic umbrellas are either white or silver. Softboxes are highly diffused and may even be double diffused with the addition of a second scrim over the lighting surface. In addition, some softbox units accept multiple strobe heads for additional lighting power and intensity.

A silver-lined umbrella produces a more specular, direct light than does a matte white umbrella. When using lights of equal intensity, a silver-lined umbrella can be used as a key light because of its increased intensity and directness. It will also produce wonderful specular highlights in the overall highlight areas of the face. Some umbrellas come with intermittent white and silver panels. These produce good overall soft light but with specular highlights. They are often referred to as zebras.

Umbrellas, regardless of type, need focusing. By adjusting the length of the exposed shaft of an umbrella in a light housing you can optimize light output. When focusing the umbrella, the modeling light should be on so you can see how much light spills past the umbrella surface. The umbrella is focused

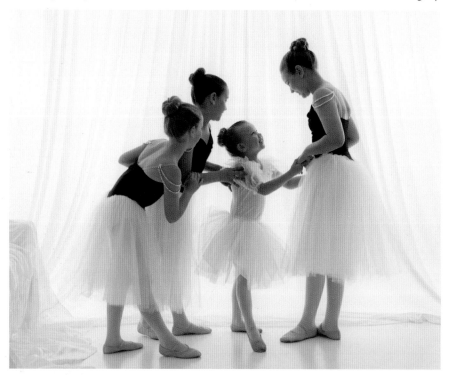

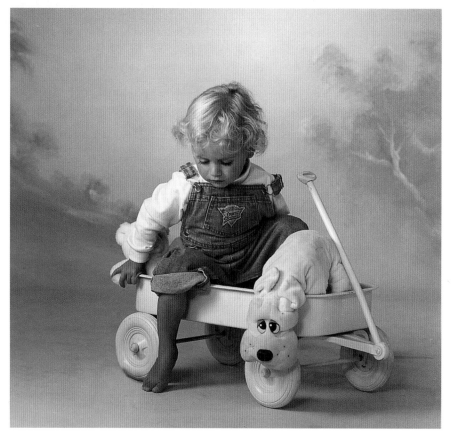

TOP: Award-winning portrait photographer Norman Phillips created this happy portrait by flooding the white background with light. As the reflected light passed through the draped white curtains it was further diffused, wrapping around the profiles of the tiny dancers. Frontal fill was accomplished by bouncing light off the back walls of the studio. **BOTTOM:** Tammy Loya created this very stylized portrait using a hand-painted wagon and beautiful hand-painted backdrop. A single diffused key light was placed high and to the left of the child. The lighting pattern produced is Rembrandt-style, with a diamond-shaped highlight on the shadow side of the child's face. The pose highlights this child's beautiful hair and eyelashes.

Backlights and Children.

While backlights like kickers and hair lights—lights that are directed from behind the subject toward the lens—are effective and provide depth and dimension, they are tricky to use with moving subjects like children. A better approach, if using backlights, is to position them above and behind the subject position. Some studios employ an overhead rail system to support such lights. The barn doors on these lights can be opened to produce a broader light, thus allowing for less precise positioning of the child.

when the circumference of the light matches the perimeter of the umbrella.

It should be noted that the closer the diffused light source is to the subject, the softer the quality of the light. As the distance between the light source and subject increases, the diffused light source looks less like diffused light and more like direct light.

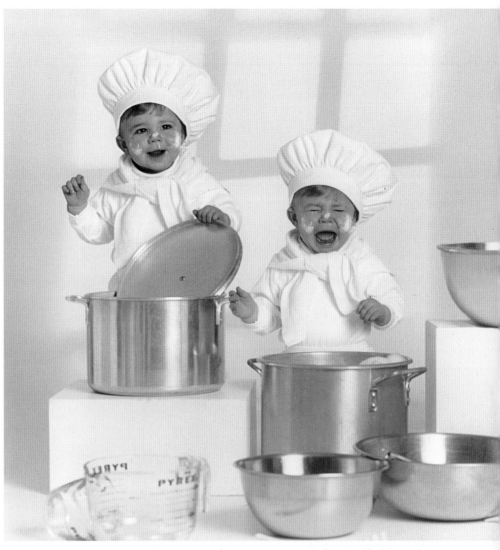

Norman Phillips created this working portrait of two not-so-great chefs. He added the outline of a window to the seamless background to add depth to the portrait. He lit the scene with broad bounce lighting from the back wall of his camera room. Notice how long and wide the highlights on the pans are and you can get an idea of how he did his lighting.

◻ LIGHTING STYLES

Broad and Short Lighting. There are two basic types of portrait lighting. Broad lighting means that the key light illuminates the side of the face turned toward the camera. Broad lighting is used less frequently than short lighting because it flattens and de-emphasizes facial contours. However, it is often used to widen a thin or long face.

Short lighting means that the key light is illuminating the side of the face turned away from the camera. Short lighting emphasizes facial contours, and can be used as a corrective lighting technique to narrow a round or wide face. When used with a weak fill light, short lighting produces dramatic lighting with bold highlights and deep shadows.

Differences Between Direct and Diffused Light. Undiffused light that emanates from a light and a parabolic reflector is sharp and specular in nature. It produces crisp highlights with a definite line of demarcation at the shadow edge. The highlights that an undiffused light source produces often have miniscule specular highlights within the overall highlight—a phenomenon often referred to as highlight brilliance.

Undiffused light sources take a great deal of practice to use well, which is probably why they are not used too much anymore. These lights must be feathered, so that the hot core of the light is not aimed directly at the subject. This allows you to use the more responsive edge of the light's core.

TOP LEFT: This wonderful portrait by Robert Love is done in broad lighting. Both girls have the lighted sides of their faces showing to the camera. A single diffused light source was used and carefully positioned not to overlight the subjects. Notice the roundness in the cheek of the girl on the right. This type of modeling is often difficult to attain with broad lighting unless you carefully feather the main light. No fill light was used. **TOP RIGHT:** This handsome portrait was made by Brian Shindle, an Ohio portrait specialist. A single box light was used to create the diffused lighting pattern. Since the box light was used close to the duo, no fill light or reflector was used. **LEFT:** Tim Kelly produced this beautiful portrait using diffused lighting to create a split-lighting pattern. A very large diffused light source was employed close to the young girl and allowed to wrap around the planes of her face, creating good dimension and modeling. A smaller diffused light was used at camera right to throw some light on the hand-painted canvas background. **FACING PAGE:** A lighting style that Ira and Sandy Ellis are using more and more frequently is short lighting. It's uncharacteristic for children, but parents like its drama. Here, a diffused key light was used to the right and behind the little girl. Bounce fill provided just enough definition to the frontal planes of the image. This image borrows from the Ellis' extensive hat, basket and suitcase collection—staples for the children's portrait photographer.

Diffused light sources are much simpler to use. They are a broad, large light source that bathes the subject in light. Softboxes, umbrellas, strip lights and all of the fancy names lighting manufacturers have come up with to name diffused light sources do precisely one thing—scatter the outgoing beam of light. As the light passes through the diffusion material of these devices it is bent in many different directions at once, causing it to become diffuse.

Not only is diffused light softer, but it is also significantly less intense

than raw light. It stands to reason that as diffused light rays are bent in an almost infinite number of ways, these light rays scatter and lose intensity.

A diffused key light is an ideal light source for photographing children's portraits. It can produce beautiful contouring of the face, but at the same time it is forgiving—if the child moves a half-foot in either direction, the exposure and lighting will remain pretty much the same. A large diffused key light often doesn't need a separate fill light since the

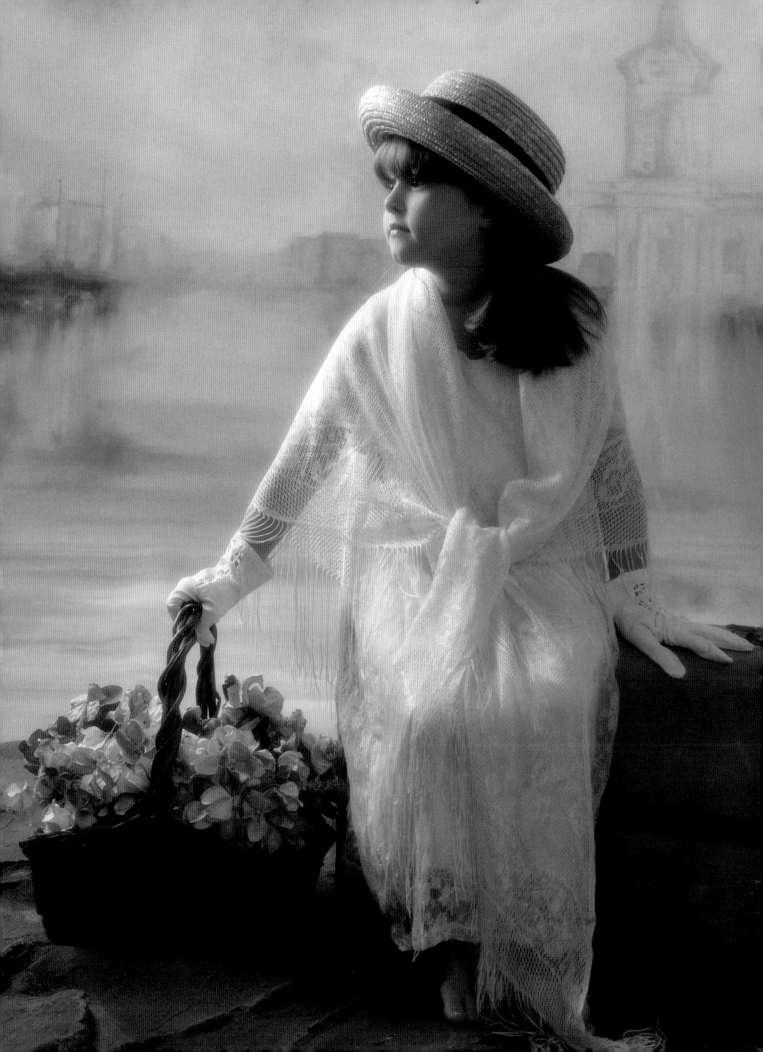

TOP: Ira and Sandy Ellis use soft light with mastery. Notice the delicate highlight detail on the baby's hand, shoulder and hair. This was achieved by using a diffused strip light overhead that also lighted the center of the hand-painted background. The key light was a large softbox placed to the left of camera; the fill light was a barebulb flash bounced into a white wall-sized white flat positioned behind the camera on the back wall of the camera room. This kind of open all-inclusive fill light washes every area of the set so there is shadow detail throughout the image. The fill light is set to a reading about 1½ stops less than the key light. **BOTTOM:** In this award-winning portrait by Rita Loy, the backlighting made all the difference, essentially defining the lighting of the portrait. There were no direct backlights used. Instead, Rita spotlighted the background, creating a higher key behind the two faces. Frontal lighting was soft, diffused and large so that the entire length of the portrait was lighted evenly. The hand-painted backdrop enhances the high-key elegance. A trademark of a Rita Loy portrait is precise and perfect tonal separation.

highlights tend to "wrap around" the contours of the face. If any fill source is needed, a reflector will usually do the job.

Master photographer Don Blair often uses a hybrid light—a broad parabolic fill with a barebulb strobe. He says that the barebulb adds a softness that you cannot get from an umbrella or other diffuser. He prefers it for photographing children because he says it wraps the child in soft, open light.

The Basic Lighting Patterns Simplified. There are five distinct lighting patterns in traditional portraiture: paramount, loop, Rembrandt, split and profile lightings. The lighting patterns are produced by the key light, which only lights

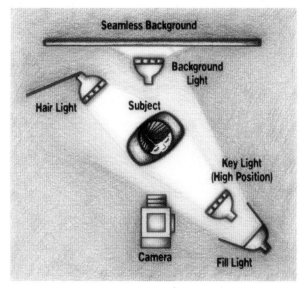

Paramount Lighting

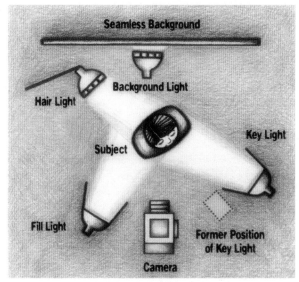

Loop Lighting

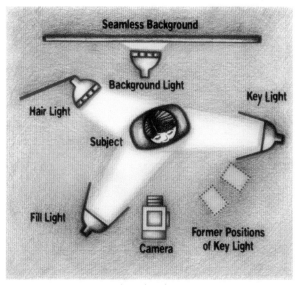

Rembrandt Lighting

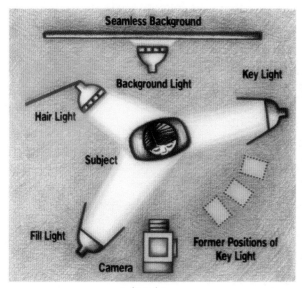

Split Lighting

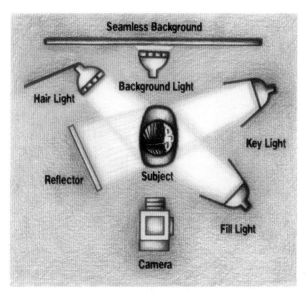

Profile or Rim Lighting

In the five basic lighting patterns (paramount, loop, Rembrandt, split and profile) the key light moves from high and on a plane with the subject's nose (paramount) to a height almost below the subject's head height (profile). Each lighting pattern has a distinct personality. Paramount and loop lighting are often referred to as glamour lighting, because they hollow out cheekbones and illuminate the eyelashes. When parabolic lights are used for these lighting patterns, well defined shadows are formed beneath the nose and lower lip of the subject. As the key light is moved lower and to the side (Rembrandt and split lighting) less of the face is highlighted, producing a more dramatic style that is often termed "masculine." With profile lighting, a highlight edge is created around the subject. Diagrams by Shell Dominica Nigro.

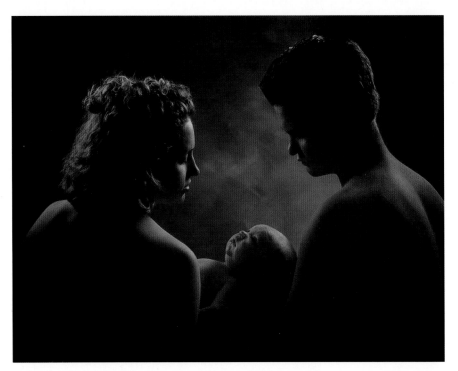

For this photograph, Dale Hansen used two key lights, one on the father and one on the mother. The mother and child are one stop lighter than the father. Hansen did this to emphasize the bond between mother and baby. The father is a bit darker and is there only in a supporting role. Hansen wanted a very low-key effect; therefore, the only fill light used was light bouncing around from the key lights. Hansen metered for the highlight on the mother. He also used a background light set at one stop less than the key light exposure. Mamiya RZ with 120mm lens. Hansen used two softboxes as key lights and one background light. Exposure: ⅟₂₅ at f/11 on Kodak NC 400.

the highlight side of the face. The different lighting patterns are distinguished by the elevation of the key light (with paramount and loop lighting, it is set high and almost directly in front of the subject's face) and how far to the side the light is (with Rembrandt and split lighting, the light is moved lower and farther around the subject). In profile lighting, the key light is set behind the subject and at a low height. These basic lighting patterns are mentioned here not as a recommendation for children's portraits, but so that you know the basics of how the key light is set.

When you use a large, diffused light source as the key light, the effects will be less visible than with an undiffused light, since the shadow edge is much softer. See the lighting diagrams on page 27 for the five key light positions.

There are a few important things to remember about the position of the key light, even if using a diffused key light. When placed high and

roughly on the same axis as the subject's nose, the lighting will be nearly overhead. Shadows will drop under the nose and chin and, to some extent, the eye sockets. Eyelashes may cast a set of diffused shadows across the eyes, and the eyes themselves will need a fill source to open up the shadows and to get them to sparkle.

As you move the light lower and farther to the side of the subject (loop and Rembrandt), the roundness of the face becomes more evident. There is also more shadow area visible on the face. These are the most dynamic lighting patterns and most photographers, as a general rule, will start with the key light roughly 30 to 45 degrees from the camera/subject axis and at a medium height.

Catchlights. Catchlights are small, specular highlights (pure white) that appear on the iris of the eye. Multiple light sources produce multiple catchlights. The secondary one is usually removed in retouching. Two catchlights tend to produce the impression of a dumb stare—a directionless gaze.

When using a diffused key light, the catchlight will be the same shape as the light source. If using a boxlight, the catchlight will be square. When a striplight is used, the catchlight will be rectangular and elongated. If using an umbrella, the catchlight will be umbrella-shaped, and so on.

In addition, if you use a second light or a reflector that adds light to the eyes, this too will be mirrored in the eyes. It is more important to fill harsh shadows than it is to worry about catchlights, but it is men-

tioned here because, if using a large reflector (especially the silvered type) the secondary catchlight can be almost as intense as that from the key light.

□ **LIGHTING RATIOS**

The term describes the difference in intensity between the shadow and highlight sides of the face and is expressed as a ratio—3:1, for example, meaning that the highlight side of the face is three times brighter than the shadow side.

Ratios are useful because they determine how much overall contrast there will be in the portrait. They do not determine the scene contrast (the subject's clothing, the background and the tone of the face determine that), but rather, lighting ratios determine the lighting contrast measured at the subject. Lighting ratios indicate how much shadow detail you will have in the final portrait.

It is important to keep the lighting ratio fairly constant. A generally

BELOW: Rita Loy created this lovely backlit portrait using the basic profile lighting setup. The key light is moved around a little more to the front than in a true profile lighting pattern so that the near cheek is highlighted. The fill light was used only to open up the shadow areas created by the key light. A small hair light was used opposite the key light to light this baby's golden tresses. **RIGHT:** Rita Loy created this beautiful high key portrait by first lighting the background from either side. She then used two frontal fill lights, both diffused to illuminate the entire portrait, top to bottom. Rita also used a kicker for the baby to produce a lovely highlight on the top of baby's head.

acceptable lighting ratio for color negative film is 3:1 because of the limited tonal range of color printing papers. Black & white films can tolerate a greater ratio—up to 8:1—although at this point it takes a near-perfect exposure to hold detail in both highlights and shadows.

Ratios are determined by measuring the intensity of the fill light on both sides of the face with a light meter, and then measuring the intensity of the key-light side of the face only. If the fill light or reflector is next to the camera, it will cast one unit of light on each side (shadow and highlight sides) of the face. The key light, however, only illuminates the highlight side of the face. If the key is the same intensity as the fill

Award-winning photographer Don Emmerich created this beautiful portrait of mother and daughter. The original lighting setup was high key with a very low lighting ratio. The lighting pattern is visible, however, even though the ratio is just barely 2:1. Digitally, Don blended highlights and reworked the background, blending image details and background to create the effect of a painted portrait.

light, then you have a 2:1 lighting ratio.

A 2:1 ratio shows minimal roundness in the face and is desirable for high key effects. High key portraits are those with low lighting ratios, light tones, and usually a white or light-toned background.

A 3:1 lighting ratio is produced when the key light is one stop greater in intensity than the fill light. This ratio yields an exposure with excellent shadow and highlight detail. It shows good roundness in the face and is ideal for rendering average faces.

A 4:1 ratio is used when a slimming or dramatic effect is desired. In a 4:1 ratio, the shadow side of the face loses its glow and the visual impact of the portrait comes from the highlights rather than from the shadows. Ratios of 4:1 and higher are considered low key portraits, which are characterized by dark tones and a dark background. Low key ratios are infrequently used for children's portraits.

A 5:1 ratio and beyond is considered almost a high-contrast rendition. Shadow detail is minimal and as a result, such ratios are not recommended for color films unless your only concern is highlight detail. The higher the lighting ratio, the thinner the subject's face will appear.

It should be noted that many photographers now refer to lighting ratios of 2.5:1 and 3.5:1, a happenstance brought about by the advent of digital handheld flashmeters, which measure light intensity in fractions (usually tenths) of an f-stop.

Good Lighting Ratios for Children. You will most often see children photographed with low to

medium lighting ratios of 2:1 to 3.5:1. Stronger ratios are more dramatic, but less appropriate for kids. You also see very little "corrective" lighting ratios with children. With adults with large or wide faces, a split lighting pattern and a 4:1 ratio will noticeably narrow the face. With children, wide faces are a happy fact of life, making them appear more cherubic.

□ **SOME FAVORITE SETUPS**
Children's portrait photographers often have a favorite basic lighting setup that they use either most of the time (because it works and they like it) or as a starting point (because they're confident in the results it produces).

Photographer Brian Shindle uses a big 4' x 6' and a secondary 2' x 4' softbox to wash his small clients in a soft directional light. The light is large and forgiving.

Some photographers use a single main light in the form of a shoot-through umbrella placed very close to the subject—less than a foot or so away. As noted earlier, the closer a diffused light source is to the subject, the softer and more diffuse the quality of the light. Shoot-through umbrellas diffuse direct light at the source, producing elegant large highlights.

Similarly, some photographers will use a softbox for babies and small children, particularly with a white background, clothing or props. The diffused light of the softbox used close to the set causes a lot of light bounce, creating an unusually soft, very clean white look.

Another popular children's lighting setup is done with a softbox and

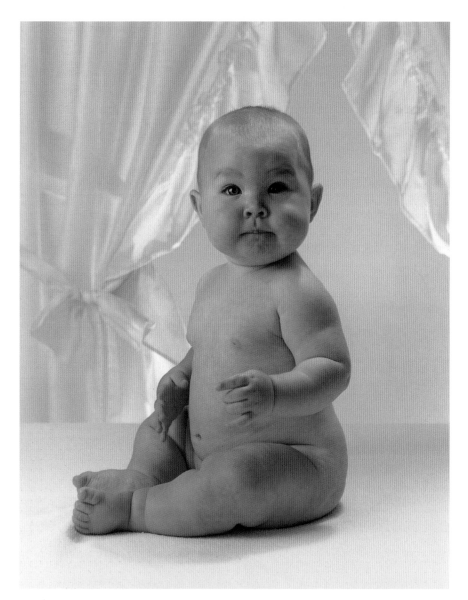

You can see the "best laid plans" of this lighting setup. The key light, soft and full, is facing the baby's chest. Gentle hair lights rim the baby's left shoulder and arm, providing beautiful depth and roundness. The baby was supposed to be looking toward the light; instead, he turned toward the camera and "fell out" of the light. Still, it's a priceless portrait of a wonderfully pudgy baby. Photograph by David Bentley.

silver reflector with the child in a profile pose. The softbox is positioned close to and facing the child, not behind the child. You are lighting the frontal planes of the face straight on, but photographing the face from the side so that the light is actually skimming the skin's surface. The light is feathered toward the camera so that the edge of the light is employed. A silver reflector, positioned between the child and the camera (but below camera level) is adjusted until it produces the maximum amount of fill-in. It is important to use a lens shade with this type of lighting because you are feathering the softbox toward the lens. You can, of course, feather the light away from the lens, toward the background, but the shot will be more difficult to fill with the reflector.

A big 4' x 4' softbox is larger than most children. When used at floor level coming from the side, it resembles window light or light coming through an open doorway. It is an excellent illusion, especially if used on location.

Outdoor and Natural Lighting

Children react well to being photographed outdoors. Youngsters are often more at ease in natural surroundings than they are in the confines of the studio. They like being outside, for the most part. Outdoor lighting represents the largest catalog of lighting configurations imaginable. You can photograph children in backlit, sidelit or frontlit situations; in bright sun or

deep shade. The ability to control outdoor lighting is really what separates the good children's photographers from the great ones. Learning to control, predict and alter daylight to suit the needs of the portrait will help you create elegant natural-light portraits consistently.

☐ FLASH AND FLASH-FILL

Bounce Flash. Portable flash units do not have modeling lights so it is impossible to see the effects they produce. However, there are certain ways to use a portable camera-mounted flash in a predictable way to get excellent fill-in illumination.

TTL flash metering systems and auto-flash systems will read bounce flash fairly accurately, but factors such as ceiling distance, color and absorption qualities can affect exposure. Although no exposure compensation is needed with these systems, operating distances will be reduced in bounce mode.

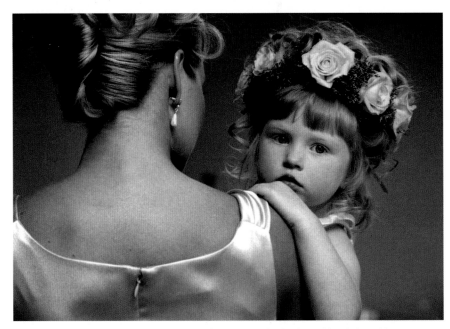

Photographer Kelly Greer made this beautiful portrait of a bride and her little girl by using simple bounce flash. Cropping in tightly and allowing some of the light to bounce off a side wall produced beautifully soft overhead lighting.

While bounce flash may not be great as a primary light source for making children's portraits, it is an ideal light source to supplement primary light sources, such as window light. Used in auto or TTL mode, you can program the flash to produce exactly the correct amount of fill-in for soft, even illumination.

Fill Flash. More reliable than reflectors for fill-in is electronic flash. A great many portrait photographers

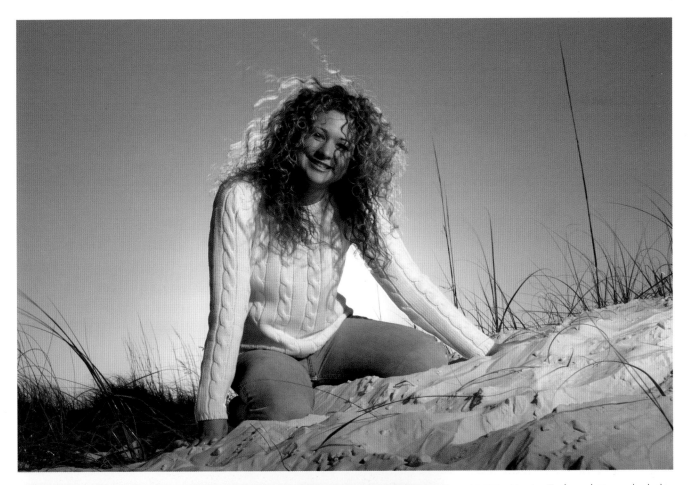

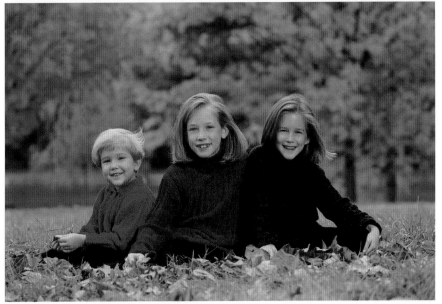

ABOVE: Monte Zucker photographed this senior on a sand dune by placing the sun directly behind her and using a barebulb flash positioned at her head height and to camera right. Instead of filling the shadows, the barebulb flash became the key light and he underexposed the background by almost two full stops to richen the colors of the sky. **LEFT:** Out in the open, the shade will be overhead in nature. Using flash opens up shadows and adds sparkle to the eyes and specular highlights to the skin. Here David Bentley used a flash at about ½ stop less than the daylight exposure. Flash also freezes hair blowing gently in the breeze.

use barebulb flash, a portable flash unit with a vertically positioned flash tube that fires the flash a full 360 degrees. With barebulb flash, you can use wide-angle lenses without flash falloff, since there is no flash reflector limiting the angle of its beam of light. Barebulb flash produces a sharp, sparkly light, which is too harsh for almost every type of photography except outdoor work. The trick is not to overpower the daylight. This is the best source of even fill-in illumination.

Other photographers like softened fill-flash. Robert Love, for example, uses a Lumedyne strobe inside a 24" softbox. The strobe is triggered cordlessly with a radio remote. He uses his flash at a 45-degree angle to his subject for a

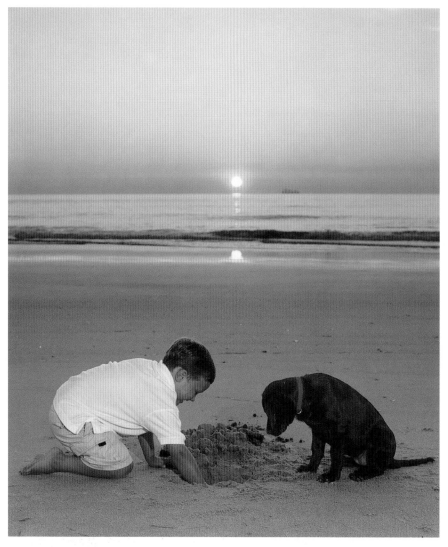

Premier environmental portrait photographer Bill McIntosh made this delightful portrait of a boy and his dog at sunset. He first calculated the exposure for the daylight, ⅟₆₀ at f/8. Then he set the flash at the same aperture, f/8. Normally you would set the flash-fill exposure to have an output of a stop less so that secondary shadows are not produced, but in this case, there was the black dog who needed to be recorded with detail.

Now, with the meter in "flash-only" mode, meter just the flash. Your goal is for the output to be one stop less than the ambient exposure. Adjust flash output or flash distance until your flash reading is f/5.6. Set the camera and lens to ⅟₁₅ at f/8. If using medium format, a Polaroid test print is a great idea.

If the light is dropping or the sky is brilliant in the scene and you want to shoot for optimal color saturation in the background, overpower the daylight exposure with flash. In the same hypothetical situation where the daylight exposure was ⅟₁₅ at f/8, now adjust your flash output or flash distance so your flash meter reading is f/11, a stop more powerful than the daylight. Set your camera to ⅟₁₅ at f/11. The flash is now the key light and the soft twilight is the fill light. The only problem with this is that you will get a separate set of shadows from the flash. This can be fine, however, since there aren't really any shadows from the twilight, but it is one of the side effects.

When using fill flash, remember that you are balancing two light sources in one scene. The ambient light exposure will dictate the exposure on the background and the subject. The flash exposure only affects the subject. When you hear of photographers "dragging the shutter" it refers to using a shutter speed slower than X-sync speed in order to expose the background properly. Understanding this concept is the essence of good flash-fill.

Flash Sync Speeds. If using a focal plane shutter as found in 35mm SLRs, you have an X-sync shutter speed setting. You cannot use flash with a shutter speed faster

modeled fill-in, not unlike the effect you'd get in the studio.

Another popular flash-fill system involves using on-camera TTL flash. Many on-camera TTL flash systems use a mode for TTL fill-in flash that will balance the flash output to the ambient-light exposure. These systems are variable, allowing you to dial in full- or fractional-stop output adjustments for the desired ratio of ambient-to-fill illumination. They are marvelous systems and, of more

importance, they are reliable and predictable. Some of these systems also allow you to use the flash off the camera with a TTL remote cord.

Determining Exposure with Flash-Fill. First, meter the scene. It is best to use a handheld incident flashmeter, with the hemisphere pointed at the camera from the subject position and the meter in "ambient" mode. In this hypothetical example, let's say the metered exposure for the daylight is ⅟₁₅ at f/8.

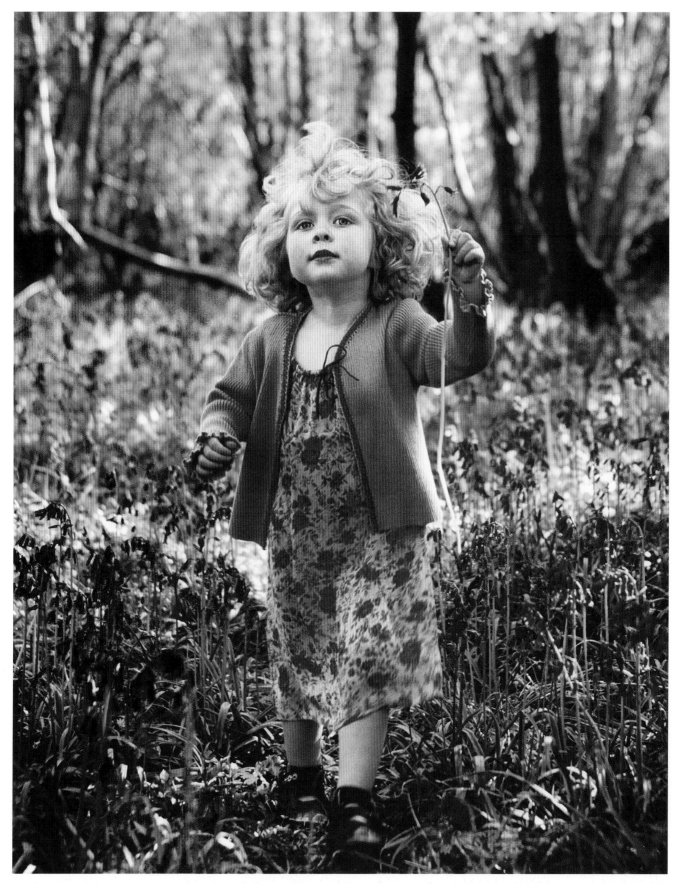

British photographer Stephen Pugh photographed this beautiful natural light portrait in shade with some thin branches overhead. The overhead branches block some of the light, allowing it to illuminate the girl more from the side. It helps too that she has her head tilted up, thus negating some of the overhead nature of the light.

One way to find directional light within shade is to move your subject under an overhang or near the corner of two walls, as was done here. Tammy Loya picked up nice edge highlights from the diffused daylight entering the scene from the right. The barn itself blocks light, creating a noticeable light ratio. Tammy also included some of the boy's favorite things—his hat, bandanna and his toy rifle.

than the X-sync speed. Otherwise, your negatives will be only partially exposed by the flash. You can, however, use any shutter speed slower than the X-sync speed safely with flash. Your strobe will fire in synchronization with the shutter and the longer shutter speed will build up the ambient light exposure.

With in-lens, blade-type shutters, flash sync occurs at any shutter speed because there is no focal plane shutter curtain to cross the film plane.

◻ **OPEN SHADE**

Unlike in the studio, in nature you must use the light that you find. By far the best place to make outdoor portraits is in the shade, away from direct sunlight.

Open shade is the shade one finds out in the open from diffused sunlight. It has an overhead nature to it that can cause "raccoon eyes"—deep shadows in the eye sockets and under the nose and lower lip. The effects of open shade are the worst at mid-day and on cloudy days, since the sun is directly overhead.

Try an experiment. Position a person out in the open on an overcast day. Examine the shadow under the person's nose. Now look at the eye sockets. Depending on the time of day and location of the sun above the clouds, these areas may be in deep shadow. It can be tricky to see.

The best shade for portraiture is found in or near a clearing in the woods, where tall trees provide an overhang above the subjects, thus blocking the overhead light. In a clearing, diffused light filters in from the sides, producing better modeling on the face than in open shade.

Even experienced photographers sometimes can't tell the direction of the light in open shade. A simple trick is to use a piece of gray or white folded card—an index card, for example. Crease the card in the middle but don't fold it, let the two sides waggle. Held vertically and pointed toward the camera, the tonal difference on the two sides of the card will tell you if the light is coming from the right or left and how intense the ratio between highlight and shadow is. Held with the crease horizontal and pointed toward the camera, the card will tell you if the light is vertical in nature, coming from above. Sometimes, using this handy tool,

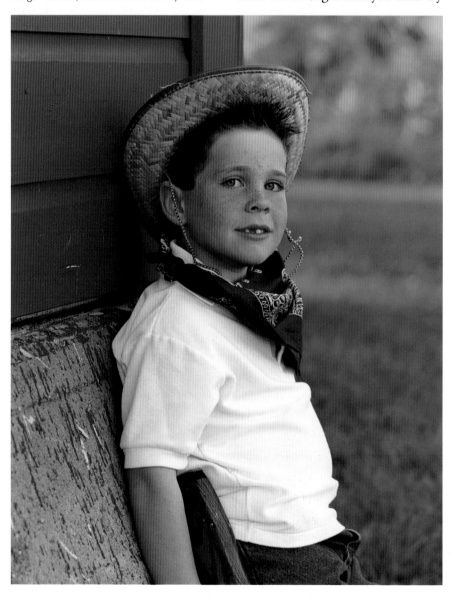

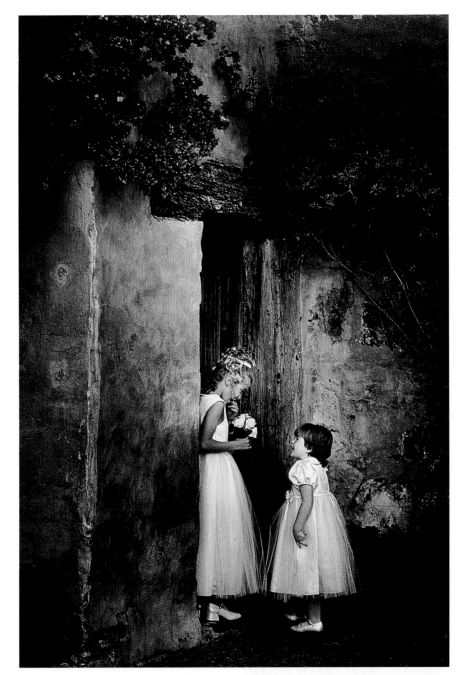

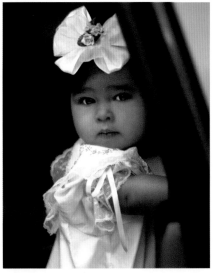

LEFT: Award-winning wedding photographer Bambi Cantrell made this delightful image at a wedding. The lighting is open shade but there are plenty of walls and overhangs around to scatter the light. Although it looks like flash-fill was used, it is more than likely shade or indirect sunlight bouncing off a nearby wall. One of Bambi's great strengths is working without being noticed, as was done here. **ABOVE:** Premier wedding photographer Jeff Hawkins was setting up to make another portrait when little Allie peeked out and this picture all but made itself. Diffuse daylight was the only light source with additional illumination kicked up by a light-colored sidewalk directly in front of the subject.

you can gauge when a slight adjustment in subject or camera position will salvage an otherwise good background.

If forced to shoot in open shade (and this is not neccessarily a bad thing—the location and background might be perfect), you must fill-in the daylight with a frontal flash or reflector. Using a silver reflector, wiggle it back and forth and watch the shadows open up as light strikes these areas. If using flash, the output should be at least one stop less than the ambient light reading in order to fill and not overpower the daylight. You will read more about this technique below.

Another popular misconception about shade is that it is always soft light. Particularly on overcast days, shade can be harsh, producing bright highlights and deep shadows, especially around noon, as mentioned. Move your subject under an overhang, such as a tree or an over-head balcony, and you will immediately notice that the light is less harsh and that it also has a good direction coming from the sides. Or make your own overhang by having an assistant hold a gobo (an opaque or black reflector) over the child's head. This will block the overhead light, allowing light to come in from the sides.

Your best bet is to look for the open shade at the edge of a tree line. The trees will block much of the

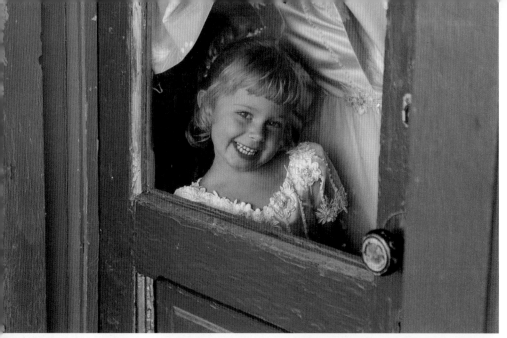

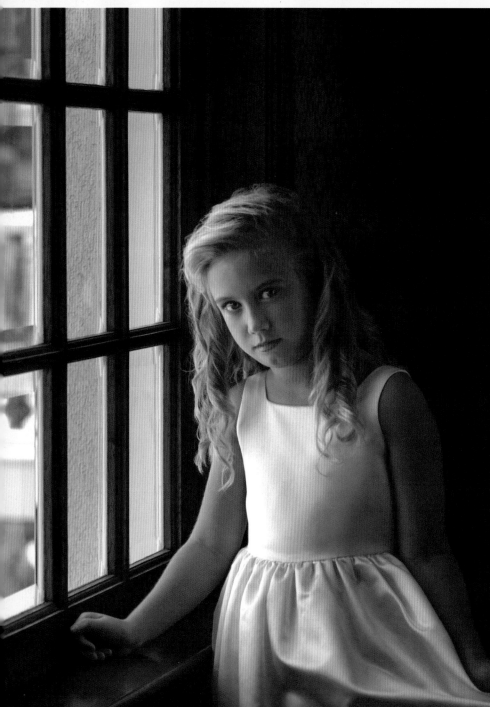

TOP: Window light is soft and creates elegant highlights. Here, master photographer Frank Frost captured a simple portrait made through a rustic green door. The qualities of window light are infinitely variable. **BOTTOM:** Award-winning wedding photographer Rick Ferro produced this beautiful and simple portrait of a flower girl at a wedding. The window light was not soft and, without a reflector for fill, would have produced a harsh lighting ratio. The light is overhead in nature, making the little girl's hair look like spun gold.

overhead light and let it filter in from the sides. Another good source for blocking overhead light is a building or several nearby buildings.

Flash-Key on Overcast Days. When the flash exposure and the daylight exposure are identical, the effect is like creating your own sunlight. This technique works particularly well on overcast days when using barebulb flash, which is a point light source like the sun. Position the flash to the right or left of the subject and elevate it for better modeling. If you want to accentuate the lighting pattern and darken the background and shadows, increase flash output to one-half to one stop greater than the daylight exposure and expose for the flash exposure. Do not underexpose your background by more than a stop, however, or you will produce an unnatural nighttime effect.

Many times this effect will allow you to shoot out in open shade without fear of hollow eye sockets. The overhead nature of the diffused daylight will be overridden by the directional flash, which creates a distinct lighting pattern.

One suggestion is to warm up the flash by placing a warming gel over

the barebulb flash's clear reflector (actually it's not a reflector, it's a clear shield used to protect the flash tube and absorb UV). The warming gel will warm the facial lighting, but not the rest of the scene. It's a beautiful effect.

□ WINDOW LIGHT

One of the most beautiful types of lighting for children's portraits is window lighting. It is a soft wrap-around light that minimizes facial imperfections, and is also a highly directional light, yielding excellent modeling with low to moderate contrast. Window light is usually fairly bright and it is infinitely variable. It changes almost by the minute and allows a great variety of moods, depending on how far you position your subjects from the light.

The larger the window or series of windows, the more the soft, delicate light produced envelops the subject. Window light seems to make eyes sparkle exceptionally brightly, perhaps because of the size of the light source relative to the subject.

Since daylight falls off rapidly once it enters a window, and is much weaker several feet from the window than it is closer to the window, great care must be taken in determining exposure. You will need reflectors to kick light into the shadow side of the face—have an assistant do this for you so you can observe the effects at the camera position.

The best quality window light is the soft light of mid-morning or mid-afternoon. Direct sunlight is difficult to work with because of its intensity and because it often creates shadows of the individual window-panes on the subject.

Award-winning photographer Gary Fagan produced this unusually soft window light portrait of a brother and sister using very fast black & white film. He purposely defocused the image so that only the essential details would be evident. Even the grain structure of the image is diffused.

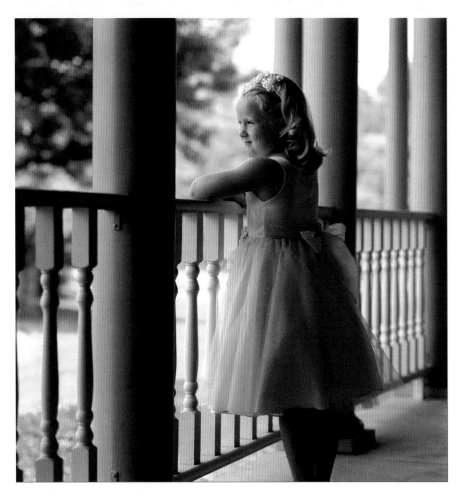

LEFT: The overhang of a porch produces diffused daylight—but with good direction. In this wonderful portrait by Michael Ayers, the direct sunlight bounced around outside the porch and was quite intense. It produced a strong, diffuse directional light, which Michael did not fill in order to produce a more dramatic lighting ratio. **FACING PAGE:** Tammy Loya's north-light window is her key light, which she uses all year long. In photographing this little girl, Tammy used no fill—just the white brim of the hat added a little fill to her face. Notice that the area below the book corresponds to the wall beneath the window where no light enters the scene. This acts like a gobo, blocking light from her dress and feet and producing a natural dark vignette in keeping with the rest of the dark tones of the portrait.

Window light can also be used as a backlight with a silver or gold reflector employed to fill-in the frontal planes of the face. This is a very popular children's portrait lighting, especially with translucent curtains hung in the windows for some diffusion. It is important to expose for the face and not the background of illuminated curtains. In some cases, the difference in exposure can be up to three stops.

Many children's photographers use a window seat in their studios. The windows, which wrap around the alcove of the window seat, produce a broad expanse of diffused daylight that is perfect for children's portraits.

Tammy Loya's studio uses a second-story 6' x 6' north-light window as the primary light source. She uses the window all year round, and 90 percent of her in-studio portraits are done by window light. Outside of Tammy's window she has painted butterflies and drawings of smiling faces—and even the alphabet for children to look at. These distractions serve another purpose as well; she can, without posing the child, have them "Look at the letter 'B'" to get perfect eye placement for the portrait.

Diffusing Window Light. If you find a nice location for a portrait but the light coming through the windows is direct sunlight, you can diffuse the window light by taping some acetate diffusing material to the window frame. Some photographers carry translucent plastic shower curtains with them just for this purpose. It produces a warm, golden window light. Light diffused in this manner has the warm feeling of sunlight but without the harsh shadows. If the light is still too harsh, try doubling the thickness of the diffusion material. Since this diffused light is so scattered, you may not need a fill source—unless working with a group of children. In that case, use reflectors to kick light back into the faces of those farthest from the window.

A tool made specifically for diffusing window light is a translucent lighting panel, such as the 6' x 8' one made by Westcott. It is collapsible for portability, but becomes rigid when extended and can be leaned into a window sill to create beautiful north light.

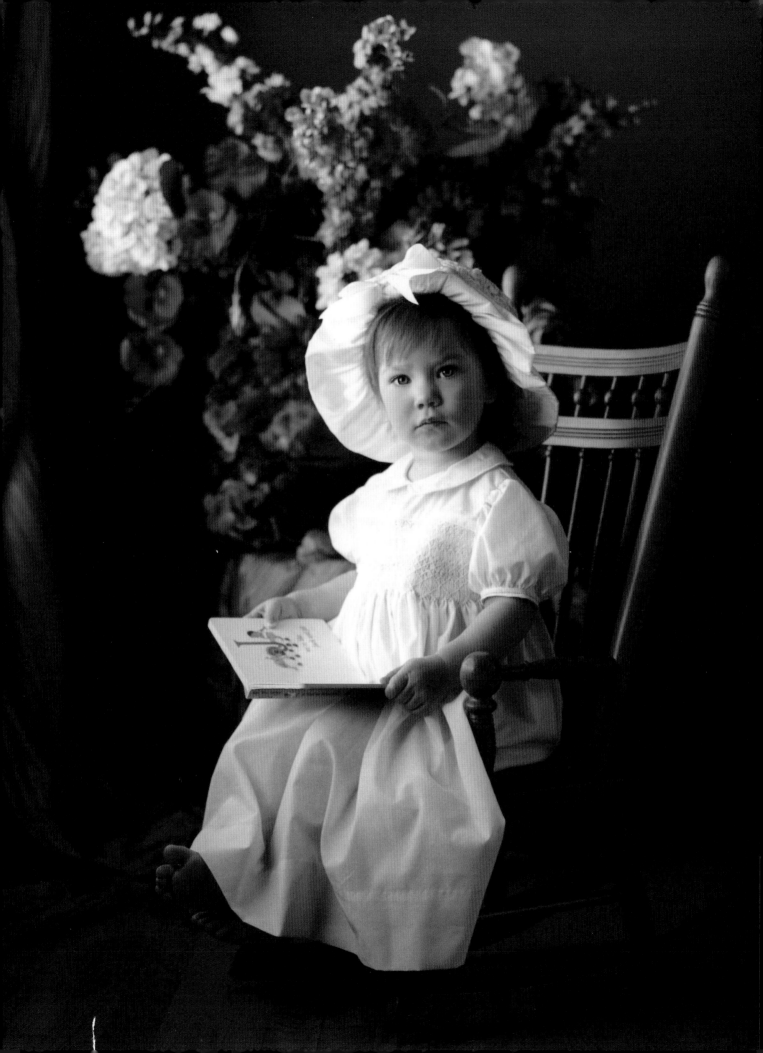

□ DIRECT SUNLIGHT

Sometimes you will want to take advantage of golden sunlight. Turn your subject so the direct sunlight is backlighting or rimlighting the child. Backlighting voids the harshness of the light and prevents your subject from squinting. Of course, you need to fill-in the backlight with strobe or reflectors and you also need to be careful not to underexpose in backlit situations. It is best to give each frame an additional third- to half-stop of exposure in backlit portraits in order to open up the skin tones.

Don't trust your in-camera meter in backlit situations. It will read the bright background and highlights on the hair instead of the exposure on the face. If you expose for the background, you will silhouette the subject. If you have no meter other than the in-camera one, move in close and take a close-up reading on your subjects. It is really best to use a handheld incident meter in backlit situations.

If the sun is low in the sky, you can use cross lighting, otherwise known as split lighting, to get good modeling on your subject. Position the child so that the light is to the side but almost behind him or her. Almost half of the face will be in shadow while the other half is highlighted. You must be careful to position the subject's head so that the sun's sidelighting does not hollow out the eye sockets on the highlight side of the face. You will need to fill-in the shadow side of the face. If using fill-flash, the flash exposure should be at least a stop less than the ambient light exposure.

It is important to check the background while composing a portrait in direct sunlight. Since there is considerably more light than in a portrait made in the shade, the tendency is to use an average shutter speed like $\frac{1}{250}$ with a smaller-than-usual

Gary Fagan created this superb late afternoon portrait by using direct sunlight. The rays of the setting sun are more diffuse near sunset than when the sun is higher in the sky. The coloration is also more flattering. Here the little girl stands out because of the bright skin tone and white dress. The composition is quite beautiful in this image.

aperture like f/11. Smaller apertures will sharpen up the background and take attention away from your subject. Preview the depth of field to analyze the background. Use a faster shutter speed and wider lens aperture to minimize background effects in these situations.

Using Scrims to Soften Sunlight. "Scrim" is a Hollywood lighting term used to define a large sheet of mesh or translucent nylon material that diffuses a direct light source. Scrims are often seen on large portable frames on movie sets. The frame is hoisted into position between the light source and the set and tied off with guide lines so that the sunlight is diffused and softened, giving a soft skylight effect.

The same technique can be used with large translucent panels, such as the Westcott 6' x 8' panel. Two assistants must hold the panel, which is a form of collapsible reflector, over your subject. If the child is seated on the grass in bright sun, for example, the scrim can be held just overhead by two assistants. The panel would be positioned so that the child and the area just in front of and behind the child is affected. If shooting at child-height, the background is unaffected by the use of the panel but the lighting on the child is soft and directional. The diffusing panel softens the light so much that no fill source is usually required.

Flash-Fill with Direct Sunlight. One variation of using flash-fill in backlit, direct sunlight situations is to use the flash at the same exposure as the daylight. The daylight will act as a background light and the flash, set to the same exposure, will act as a key light. If your exposure is ¹⁄₅₀₀ at

f/8, for example, your flash output would be set to produce an f/8 on the subject. Use the flash in a reflector or diffuser of some type to focus the light. Position the flash to either side of the subject and elevate it to produce good facial modeling. An assistant or light stand will be called for in this lighting setup.

Even if your strobe has a modeling light, its effect will be negated by the sunlight. Without a modeling light it's a good idea to check the lighting with a Polaroid test print. In the least desirable portrait lighting—direct sunlight—this setup produces beautiful results.

□ **TWILIGHT TIME**
The best time of day for making great portraits is just after the sun has set. The sky becomes a huge softbox and the effect of the lighting on your subjects is soft and even, with no harsh shadows. Because the setting sun illuminates the sky at a

low angle, you have none of the problems of overhead shade.

There are two problems, however, with working at twilight. One, it's dim. You will need to use medium to fast films combined with slow shutter speeds, which can be problematic with children. Working in subdued light also forces you to use wide lens apertures, restricting depth of field. Another problem in working with twilight is that it does not produce catchlights in the eyes of the subjects. For this reason, most photographers augment the twilight with some type of flash, either barebulb flash or softbox-mounted flash, which provides a twinkle in the eye and freezes subject movement.

□ **PROBLEMS OUTDOORS**
One thing you must be aware of outdoors is subject separation from the background. Dark hair against a dark green forest background will create a tonal merger. Controlling

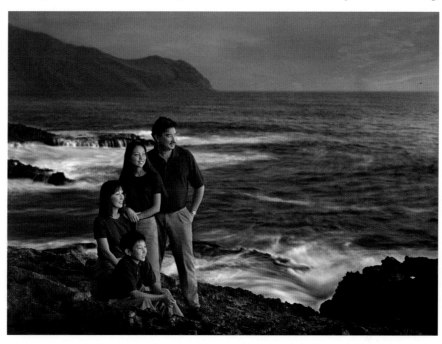

Master photographer Don Emmerich created this gorgeous family portrait at twilight. The family faced the light without looking into the setting sun. The result is beautiful wraparound lighting that requires no fill-in.

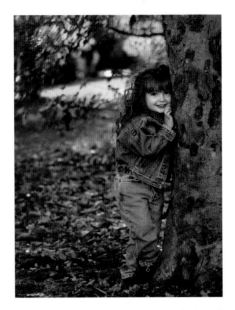

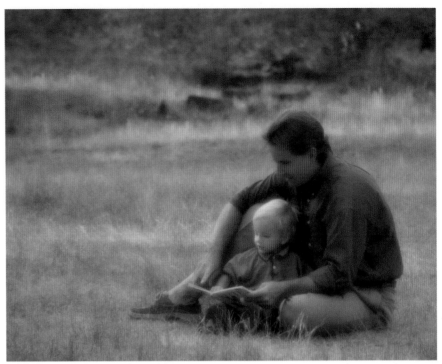

ABOVE: Anthony Cava posed this little girl under a big tree with a beautiful mottled daylight background. The only way he could get a sparkle in her eyes was to use flash. He used the flash at two stops less than the daylight exposure reading so its effect was barely noticed—except for the catchlights in her eyes. **RIGHT:** Photographer Robert Love solved several problems in this image. First, it was strongly backlit, so he biased his exposure toward the shadows, allowing the highlights to burn out. Second, there was still a lot of contrast. The fast, grainy color film he chose helped reduce contrast, as did a helping of on-camera diffusion, which further limited image contrast. The result is a beautifully handled portrait of father and son.

the amount of flash fill or increasing the background exposure will solve the problem.

Sometimes you may choose a beautiful location for a portrait, but the background is totally unworkable. It may be a bald sky or a cluttered background or a mottled background with patches of sunlight. The best way to handle such backgrounds is with a soft-focus filter or vignette. The soft-focus filter lowers the overall contrast of the scene and background, and fill flash can then

be used to raise the light level on the subjects. A vignette masks out unwanted areas of the background or foreground. Vignettes are black or white opaque or transparent filters, which fit into a bellows-type lens shade. The vignette can be moved closer or farther away from the lens to vary the effect. Since the vignette is so close to the lens, it will automatically be out of focus unless you are stopped down to an intermediate or small f-stop.

Another problem you may encounter outdoors is excess cool coloration in portraits taken in shade. If your subject is near a grove of trees surrounded by foliage, there is a good chance that green will be reflected onto your subject. If your subject is exposed to clear, blue open sky, there may be an excess of cyan in the skin tones.

While you are setting up, your eyes will acclimate to the off-color rendering, and the color cast will seem to disappear. Color film is not as forgiving. Study the faces careful-

ly and especially note the coloration in the shadow areas of the face. If the color of the light is neutral, you will see gray in the shadows. If not, you will see either green or cyan.

To correct this coloration, use color compensating (CC) filters over the lens. These are usually gelatin filters that fit in a gel filter holder or a pro lens shade, like the ones that are used to hold vignettes. To correct for excess green coloration, use a CC 10M (magenta) or CC 15M filter. To correct for cyan coloration, use a CC 10R (red) or CC 15R filter. This should neutralize the color shift in your scene. Alternately, you can use warming filters, of which there are quite a few. These will generally correct the coolness found in shaded scenes. Also, fill flash will generally wipe out a color shift in the shadows, particularly if the flash output matches or is close to the ambient light exposure.

Reflectors. You are at the mercy of nature when looking for good lighting on location. Therefore, it is

a good idea to carry along several portable reflectors. Reflectors should be fairly large—the larger they are, the more effective they will be. Portable light discs, which are reflectors made of fabric mounted on a flexible, collapsible circular frame, come in a variety of diameters and surfaces—white, silver or gold foil (for a warming fill light), translucent (so that the reflector can be used as a scrim) and black (for subtractive effects).

When the shadows produced by diffused light are harsh and deep, or even when you just want to add a lit-tle sparkle to the eyes of your subjects, use a large reflector or even several reflectors. You will need an assistant so that you can observe the effect at the camera position. Be sure to position the reflectors outside the frame. With foil-type reflectors used close to the subject, you can some-times overpower the ambient light, creating a pleasing and flattering lighting pattern.

One effect of using reflectors is that they will sometimes make the child squint. If you notice this hap-pening, back off somewhat or change the angle of the reflector(s).

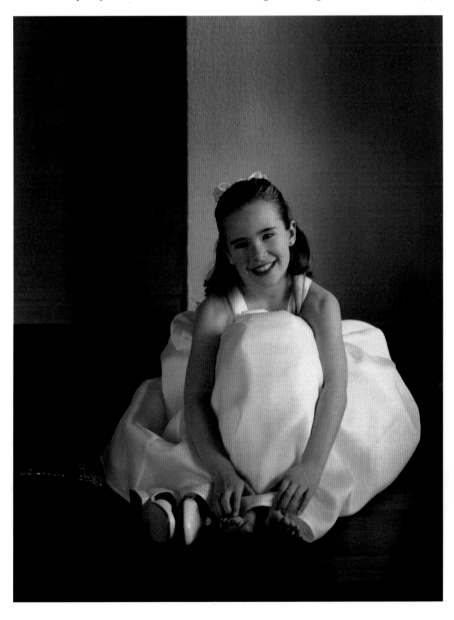

LEFT: Anthony Cava created this beautiful window light portrait of a young girl with her shoes off. Anthony used a silver reflector to kick light back into the shadow side of the portrait. The soft window lighting enhances the relaxed mood of the portrait. **BELOW:** One of the problems with working outdoors is that colors will get reflected into skin tones. Here, Heidi Mauracher used the warmth of the sandstone to warm up the skin tones of these brothers. Notice the formal posing and informal portrait. Many photog-raphers will eliminate shoes because they tend to date a portrait, especially of kids.

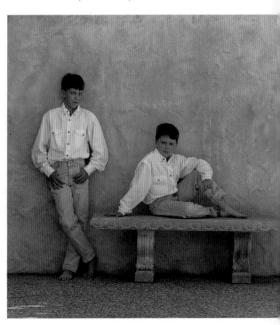

Posing and Composition

The guidelines for posing are formalized and steeped in a long tradition dating back to Greek civilization. These rules offer flattering ways to depict subjects. Like all rules, especially artistic ones, they are made to be broken. Without innovation, portraiture would be a static, scientific discipline, devoid of emotion and beauty. While you cannot attempt complex posing with

children, a few basics are essential to good portraiture and are really not that difficult to attain, even with small children.

□ POSING

Subject Positioning. First and foremost, do not photograph a child (or adult) head-on, shoulders square to the camera. This is the mug-shot type of pose and, while it is acceptable in close-up portraits, it is generally not recommended. The shoulders should be at an angle to the

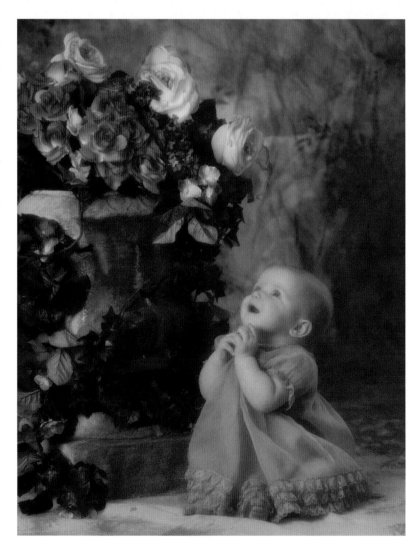

Award-winning Canadian photographer Frances Litman created this stunning baby portrait. Notice how the baby's shoulders were turned 45 degrees to the camera and that Frances captured the baby in a three-quarter facial view so the lighting shows good roundness and dimension. The baby was seated with one leg bent to give her a little stability. Frances made the baby relatively small to create interplay between the large floral arrangement and the tiny baby.

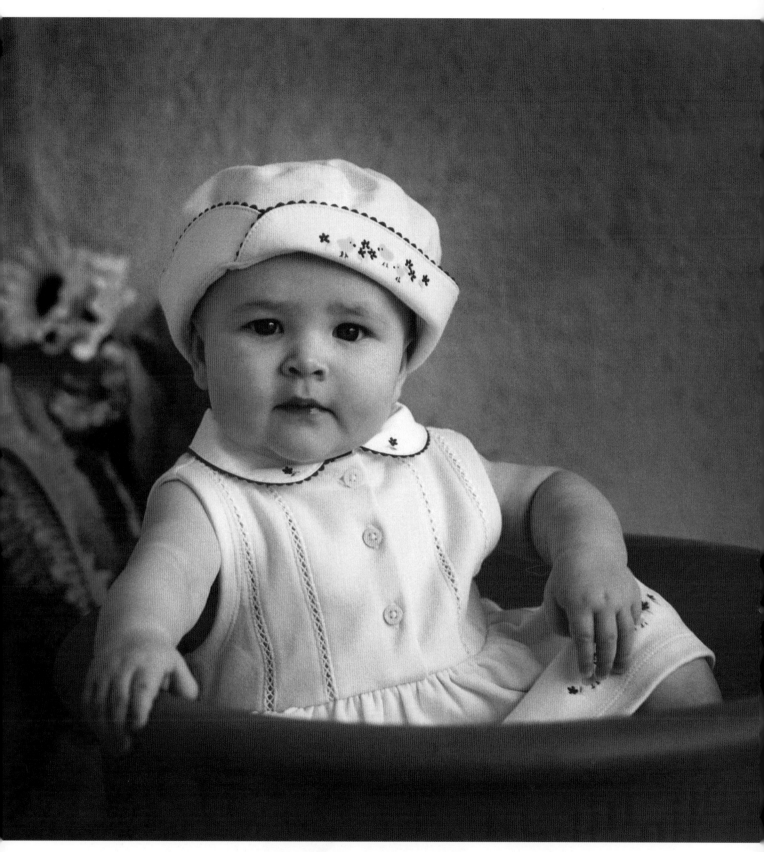

What makes this portrait so delightful is the grown-up, self-assured pose. Anthony Cava turned the girl so her shoulders were not square to the camera. Her head was on a different axis than her shoulders, for a dynamic pose. The little one's hands were perfectly posed as well, producing a very sophisticated portrait.

camera. This is easily accomplished by arranging any posing stools, chairs or blocks on an angle to the camera so that when the child is put into the scene, the shoulders are already turned. This technique introduces a visually pleasing diagonal line into the composition.

The Head-and-Shoulders Axis. Turning the shoulders is the first step in posing a child. Step two, which is often a function of luck with children, is to turn the head to a slightly different angle than the angle of the shoulders, thus introducing a second dynamic line into the composition. In traditional male portraiture, the head is more often turned the same direction as the shoulders, but with women, the head is usually turned to an opposing angle. The only reason this is mentioned is so that you are aware of the difference.

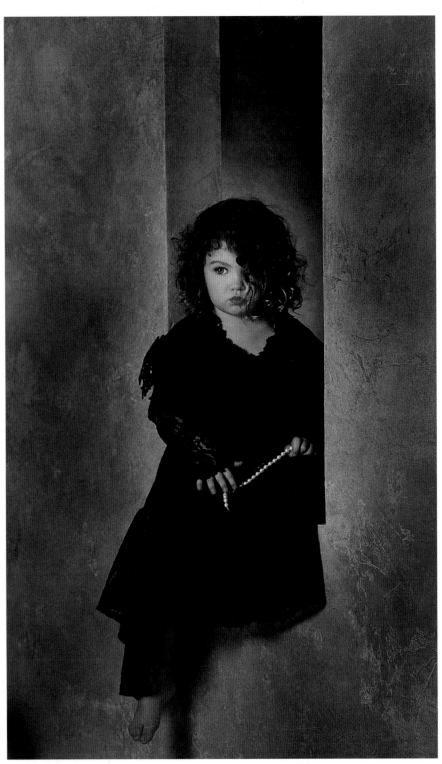

LEFT: Tammy Loya created great drama in this portrait by refining some of the basic posing rules. In order to make the child look more dominant in the image, Tammy photographed her with shoulders square to the camera. Yet she attained a dynamic pose by having the little girl look toward the light. The use of a grown-up costume and hairstyle also add visual interest and drama to the portrait, as does the single eye showing. The finger puzzle is the perfect "prop" to get the little girl to do something interesting with her hands. **FACING PAGE:** Ira and Sandy Ellis maintain a fully-stocked studio, including three rocking horses. In this lovely portrait, the team photographed this young lad in a ⅞ facial view, which allows the lighting to show roundness in the shadow side of his face.

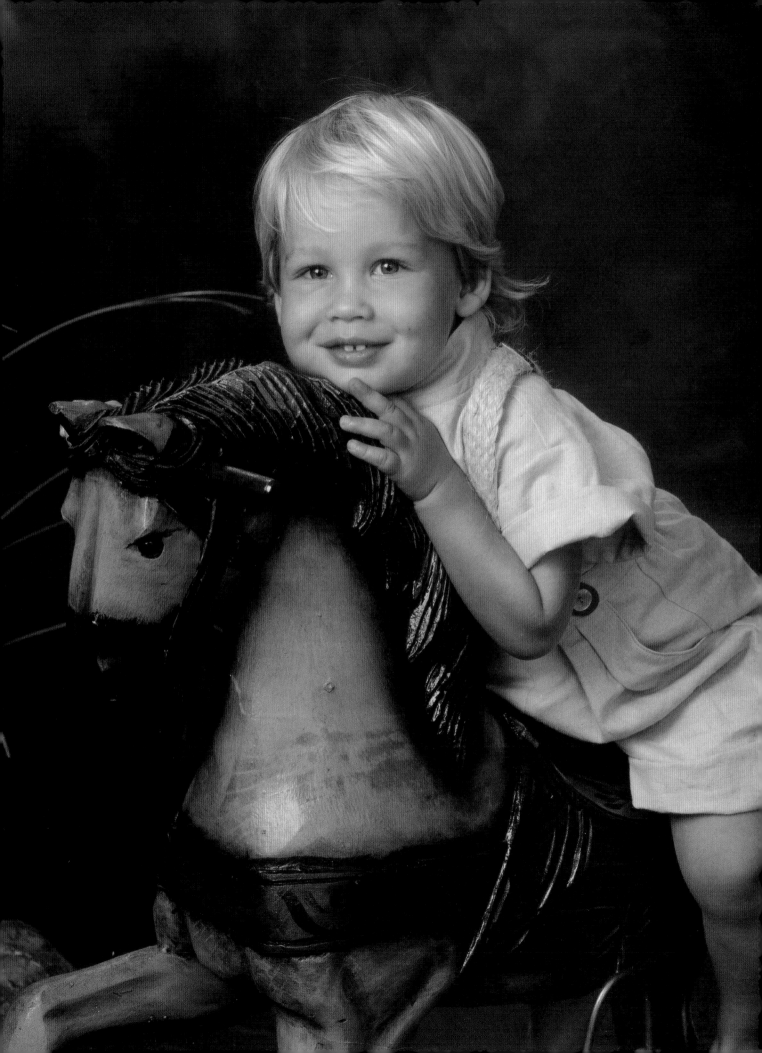

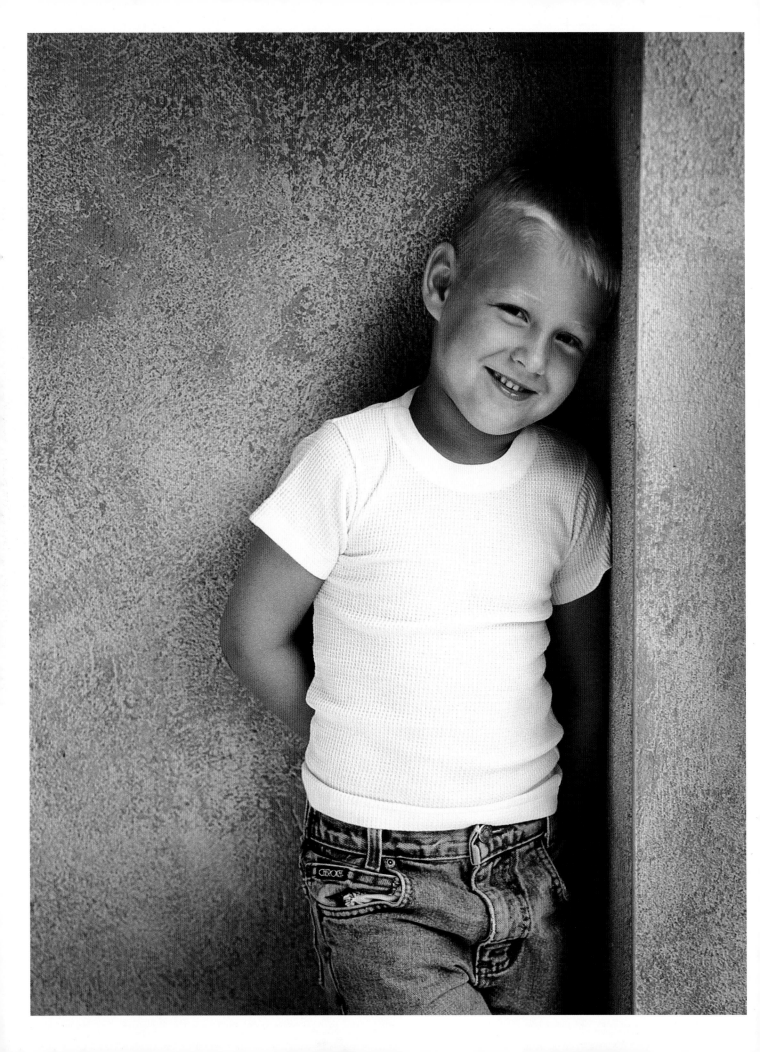

You can often redirect the line of the child's head by having your assistant hold up something interesting within eyesight of the child and move it in the direction that turns the child's head slightly. By turning the shoulders and face slightly away from the camera, you allow the frontal planes of the face to be better defined with light and shadow.

Arms and Hands. Regardless of how much of the child is visible in the viewfinder (i.e., head and shoulders, three-quarter or full-length), the arms should not slump to the child's sides. Often by giving the child something to hold, the hands will come up so the child can more closely inspect the object. This creates a bend in the elbows and introduces more dynamic lines to the composition. Not only are a child's hands interesting, but having them visible means that the elbows are bent, thus providing a triangular base to the composition, which attracts the viewer's eye upward, toward the child's face.

Face Positions. There are three basic face positions in portraiture. They dictate how much of the face is seen by the camera. The seven-eighths view is when the subject is looking slightly away from the camera. From the camera position, you see slightly more of one side of the face than the other. You will still see the subject's far ear with this pose.

With a three-quarter view, the far ear is hidden from the camera and more of one side of the face is visible. The far eye will appear smaller because it is naturally farther away from the camera than the near eye. It is therefore important when posing the child in this view to position him

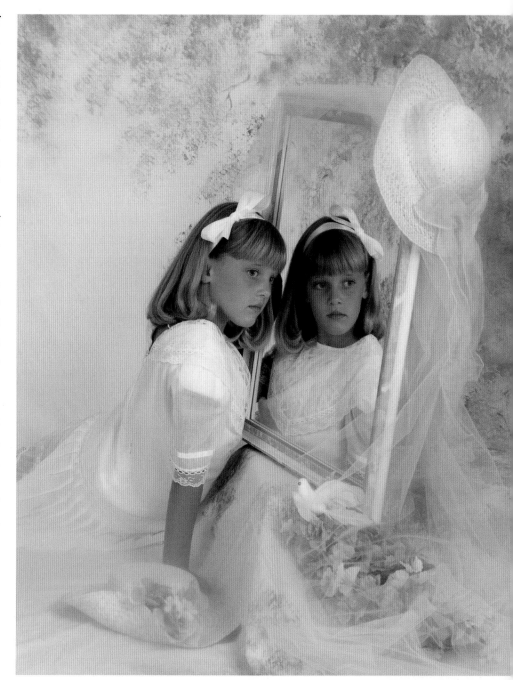

ABOVE: In this artfully made portrait by Susan Bentley, the tilt of the girl's head produced a dynamic angle, but functionally, also allowed the other side of her face to be pictured in the mirror. **FACING PAGE:** Anthony Cava made this priceless portrait. He found a natural alcove in the sandstone wall that provided beautiful wraparound lighting. Notice too how he solved the problem of showing the boy's hands, which can often be problematic in posing, by hiding them behind the boy's back, a rather typical stance for a small boy. Even though the shoulders are parallel to the film plane, the tilt of the head and the ⅞ view make this a dynamic portrait.

David Anthony Williams created this wonderful portrait of a little girl showing off her flower girl dress. She is leaning forward and, with the subtle tilt of her head, she is asking, "Isn't it beautiful?" David's backgrounds are always of interest. Here you see a figure, probably the little girl's mother, hand on hip, not so patiently waiting to get the little girl dressed.

or her so that his smallest eye (people usually have one eye that is slightly smaller than the other) is closest to the camera, thus making both eyes appear normal size.

In the profile, the head is turned almost 90 degrees to the camera. Only one eye is visible. In posing a child in profile, have your assistant direct the child's attention gradually away from camera position. When the eyelashes from the far eye disappear, your subject is in profile.

With all three of these head poses, the shoulders should remain at an angle to the camera.

Tilting the Head. So far, all of the posing guidelines are easily accomplished even with small children. Their attention can be diverted to get them to look in the direction that adds the right dynamics to the pose. Alternately, you can pre-arrange the posing furniture at the precise angle you want to the camera lens. The tilt of the head is another matter because it involves a movement that is more physically complex.

There are only two ways to tilt the child's head, toward the near shoulder or toward the far shoulder.

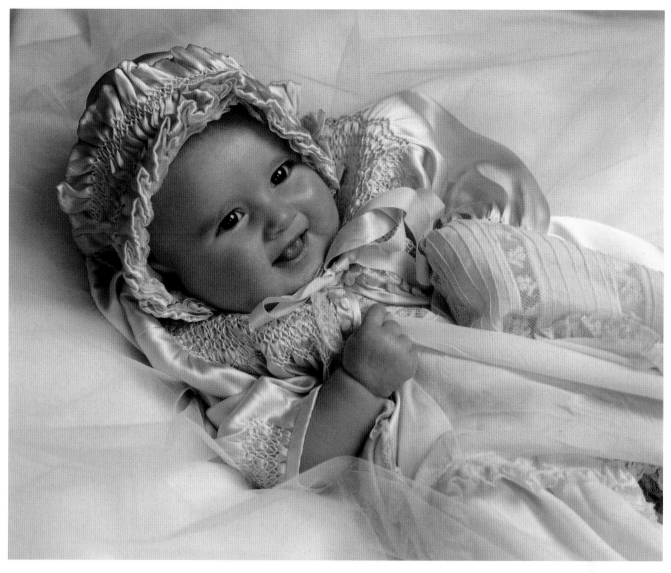

Eye contact with babies and adults is essential to making a lasting portrait. Communication is what enlivens the subject's eyes. Here, master children's portrait photographer David Bentley stood between the camera and the light and was obviously amusing this little one as he made the picture. Notice that the eyes are not on the same angle as the head. She is looking in toward David, but not at the camera.

Which way depends on the composition and lighting. You can ask your assistant to tilt his or her head slightly and ask the child, "Can you do this?" but usually you will get an exaggerated version of the pose. Although difficult to achieve, this posing point is mentioned here only because it introduces yet another dynamic line into the composition.

The Eyes. A child's eyes reflect all of the innocence and vulnerability that are the essence of childhood. For this reason, it is imperative that the eyes be a focal point of any children's portrait.

The best way to keep the child's eyes active and alive is to engage him or her in conversation or a game of some type. If the child does not look at you when you are talking, he or she is either uncomfortable or shy. In extreme cases you should let Mom do all of the enticing. Her

voice is soothing and will elicit a positive expression.

The direction in which the child is looking is important. Start the session by having the child look at you. Using a cable release with the camera tripod-mounted forces you to become the host and allows you to physically hold the child's gaze. The basic rule of thumb is that you want the eyes to follow the line of the nose. When your assistant holds an object for the child to see, have him or her move it back and forth, so that the eyes follow the object.

The colored part of the eye, the iris, should border the eyelids. In other words, there should not be a white space between the top or bottom of the iris and the eyelid. If there is a space, redirect the child's gaze.

Camera Height

Be aware of the positive and negative effects of perspective when posing children. For a head-and-shoulders portrait, camera height should be mid-face, or nose height. Too high a camera position will narrow the child's cheeks and chin. With too high a camera height, you will distort the shape of their heads. This holds true for three-quarter length and full-length poses as well. Camera height, especially with shorter focal lengths, should be midway between the top and bottom of the child's body.

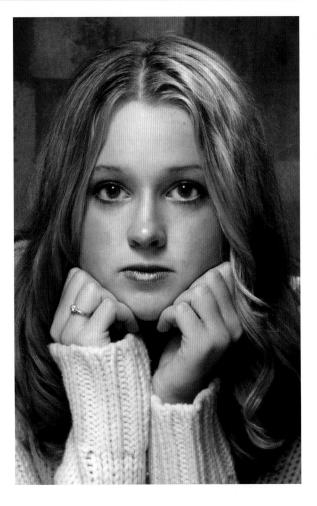

Monte Zucker made this portrait for one reason—the young woman's eyes, which are gorgeous. Monte lit the portrait from above in a classic butterfly lighting pattern that places dramatic catchlights in the traditional eleven o'clock position.

Pupil size is also important. If working under bright modeling lights (strobes are recommended over incandescent lights because of the heat factor), the pupils will contract. A way to correct this is to lessen the intensity of the modeling lights. You can always increase the intensity to check the lighting pattern and quality. Just the opposite can happen if you are working in subdued light. The pupils will appear too large, giving the child a vacant look.

Hands. A child's hands are delicate and beautiful and should be included in a portrait whenever possible. While it is impossible to pose hands, other than by giving the child something to hold, you can gain some control by varying subject distance and focal length. If using a short focal length lens, for example, hands will be close to the camera and appear larger than normal. Using a slightly longer-than-normal focal length sacrifices the intimacy of working close to the child, but corrects the perspective and controls this situation. Although holding the focus of both hands and face is more difficult with a longer lens, the size relationship between them will appear more natural. And if the hands are slightly out of focus, it is not as crucial as when the eyes or face are soft.

While the vast majority of hand poses are not particularly useful to this discussion, it should be noted that the most flattering results are obtained when the edge of the hand is photographed, as hands pointing straight into the lens appear "stumpy." Also, where possible, fingers should be photographed with

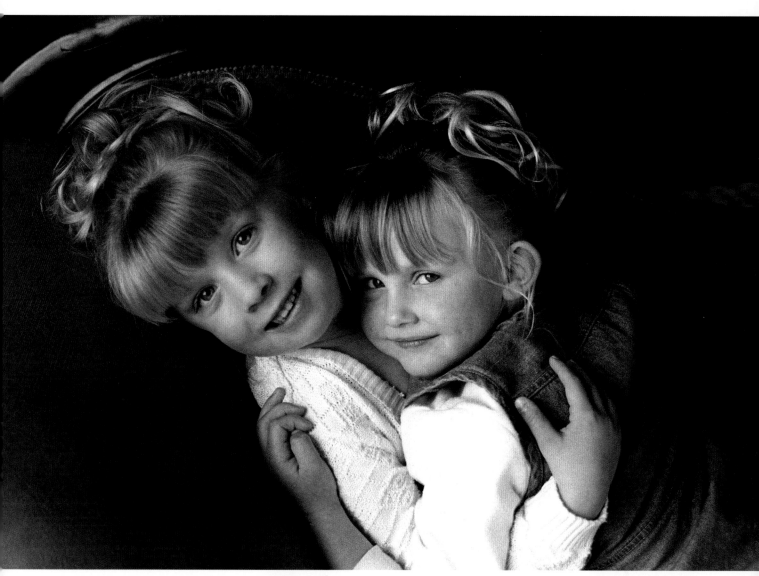

David Williams made this sweet portrait of two sisters and incorporated some very sophisticated design elements. The V shape formed by the arms of the girls leads the eye up to their faces and frames the portrait. The flowing S shape formed by the sofa back is not only pleasing and rhythmic, it mimics the basic line of the composition.

slight separation. While it is impractical to do much about hands with children, it is useful information to know.

Three-Quarter and Full-Length Poses. Where children are concerned, the difference between three-quarter length and full-length poses is quite slight. There are a few things you should keep in mind, however. In three-quarter length poses (those that do not show the entire body), you should never "break" the composition at a joint—at the ankles, knees or elbows. It is visually disquieting.

A three-quarter–length portrait is one that shows the subject from the head down to a region below the waist. This type of portrait is best composed by having the bottom of the picture be mid-thigh or below the knee and above the ankles.

A full-length portrait shows the subject from head to toe. A full-length portrait can be made standing or sitting, but it is important to remember to slant the child to the lens or adjust your camera position so that you are photographing the child from a slight angle. The feet, ordinarily, should not be pointing into the lens.

When the child is standing, hands become a real problem. If you are photographing a boy, have him stuff

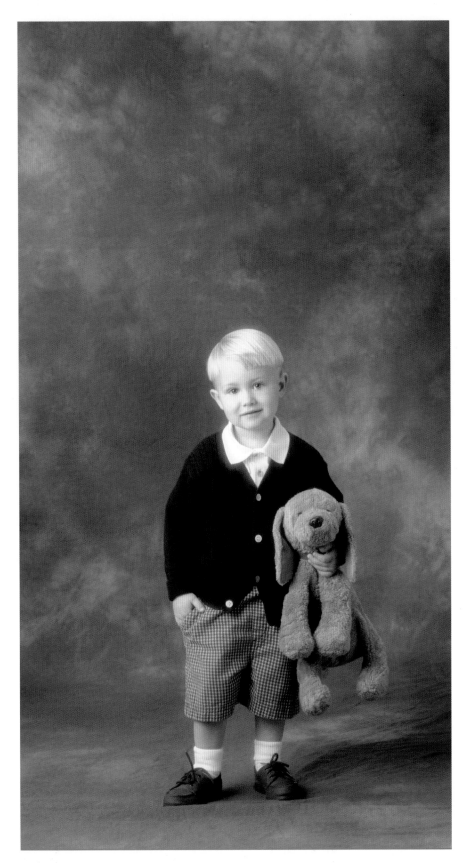

Brian Shindle created this endearing portrait with very soft light—a softbox to the left of the camera and another soft light from above. Brian had the boy thrust his hand in his pocket "like a big guy," and the effect is a very charming pose. Notice how Brian had this little guy hitch his thumb over his pocket so the hand remained visible. The boy was photographed head-on but positioned low and small in the frame so he attains his visual dominance in the portrait not by size but by location.

his hands in his pockets—it's an endearing pose. You can also have him fold his arms, although children sometimes adopt a defiant stance in this pose. With a little girl, have her put one hand on her hip, making sure you can see her fingers. Full-size chairs make ideal props for standing children because the child's hands can easily be posed on the arm of the chair or along the chair back.

When a little child is sitting, a cross-legged pose is good, as is the "tripod-pose," in which one leg is curled under the other.

It should be noted that in any discussion of subject posing, be it for children or adults, the two most important points are that the pose appear natural (one that the subject would typically fall into), and that the person's features be undistorted.

□ **COMPOSITION**

Composition in portraiture is no more than good subject placement within the frame. There are several schools of thought on proper subject placement, and no one school is the only answer.

A simple formula for subject placement is the rule of thirds. The rectangular viewfinder is dissected

into nine separate quadrants by four lines. Where any two lines intersect is an area of dynamic visual interest. The intersecting points are ideal spots to position your main point of interest, i.e., the subject or the eyes of the subject.

The subject of the composition does not necessarily have to be placed at an intersection of two lines; he or she could also be placed any-where along one of the dividing lines. In head-and-shoulders por-traits the eyes are the region of cen-tral interest, so it is a good idea if the eyes are placed on a dividing line or at the intersection of two lines. In a three-quarter or full-length portrait, the face is the center of interest—thus, the face should be positioned to fall on an intersection or on a dividing line.

David Williams photographed these two sis-ters playing with their heart-shaped neck-laces. The trick with kids and hands is to give them something fun to do with them.

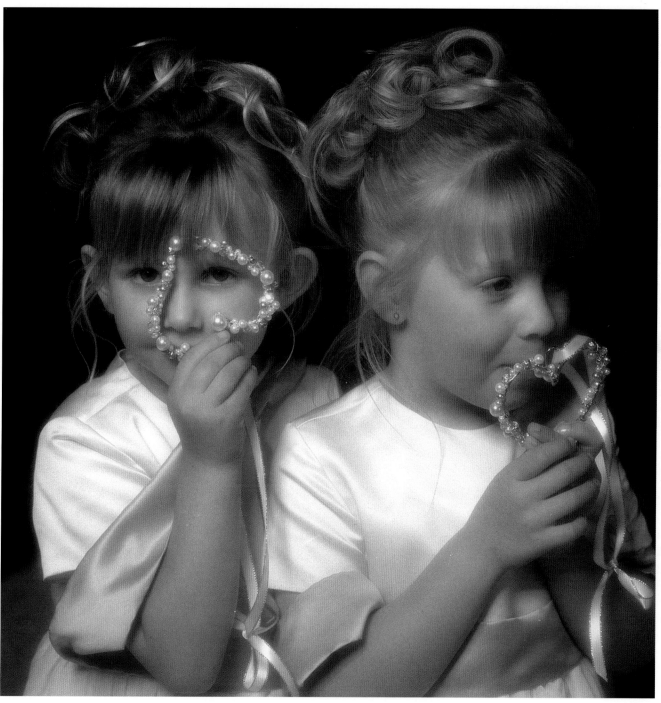

Usually the head or eyes are two-thirds from the bottom of a vertical photograph. Even in a horizontal composition, the eyes or face are usually at the top third of the frame, unless the subject is seated or reclining. In that case, they would generally be at the bottom third line.

Direction. Regardless of which direction the child is facing in the photograph, there should be slightly more room in front of the child than behind him. For instance, if the child is looking to the right as you look at the scene through the viewfinder, then there should be more space to the right side than to the left of the child in the frame. This gives a visual sense of direction.

Even if the composition is such that you want to position the child

This beautiful low-key portrait by Rita Loy features a little girl delicately posed against an antique chair. The chair and the subject are balanced size-wise. Rita handled the hand posing beautifully, working with the edges of the young girl's hands. She also showed off those wild black boots, which are a prized possession of the subject. The dark tones and tapestry backdrop make this portrait look like it could be 100 years old.

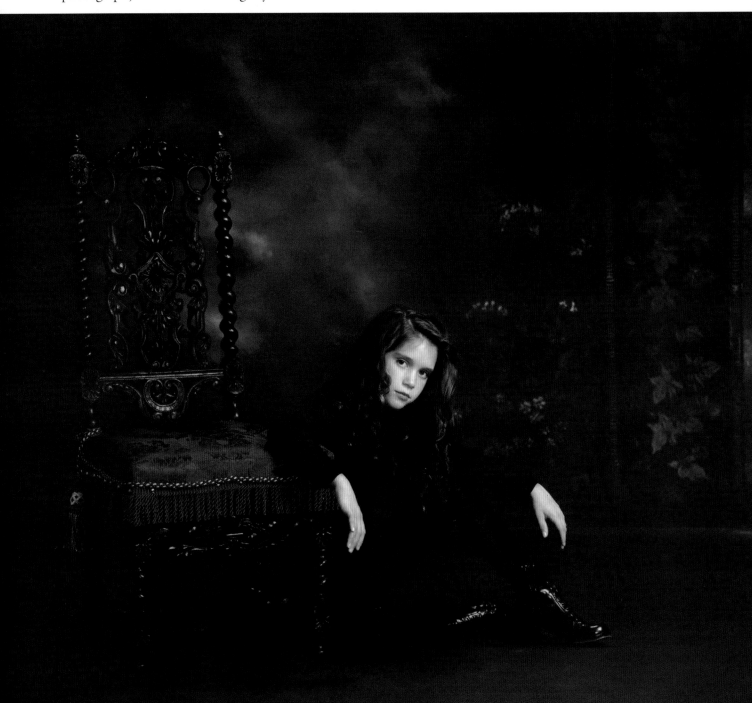

very close to the center of the frame, there should still be slightly more space on the side toward which he or she is turned. When the subject is looking directly at the camera, he or she should still not be centered in the frame. There should be slightly more room on one side or the other to enhance the composition.

Pleasing Compositional Forms. Shapes in compositions provide visual motion. The viewer's eye follows the curves and angles as it travels logically through the shape and consequently through the photograph. Subject shapes can be contrasted or modified with additional shapes found either in the background or foreground of the image.

The S-shaped composition is perhaps the most pleasing of all. The center of interest will usually fall on a third line, but the remainder of the

TOP: Even when a subject is centered in the frame, it's always a good idea to place slightly more room in front of or behind the subject to imply direction. Here, Jerry D created this wonderful portrait of a tired clam digger at the beach. He "worked" the sky in Photoshop to give the image a surreal edge. **BOTTOM:** Master photographer Barbara Rice found this incredible stone wall and used it to produce a striking profile of a young girl. Barbara placed the stone cutout in one of the rule of thirds quadrants.

This image by Robert Love has won numerous awards. It has great design qualities. Note the curved diagonal shape that is repeated three times in the image—the dark foliage at right, the girl and the kite and, finally, the ripple in the wild mustard above the girl. Various secondary diagonals are also repeated throughout the composition, lending both a sense of untiy and visual diversity. Notice too how Robert positioned the girl in a quadrant of the rule of thirds. She is running into the main space of the photo, implying direction and movement.

composition forms a gently sloping S shape that leads the viewer's eye to the area of main interest.

Another pleasing type of compositional form is the L shape or the inverted L shape. This occurs when the subject's form resembles the letter L or an inverted letter L. This type of composition is ideal for reclining or seated subjects. The C and Z shapes are also seen in all types of portraiture and are both visually pleasing.

The classic pyramid shape is one of the most basic in all art, and is dynamic because of its use of diagonals with a strong horizontal base. The straight road receding into the distance is a good example of a found pyramid shape. When photographing more than one child at a time, the photographer should consciously arrange the subjects to form such basic shapes.

Line. To effectively master the fundamentals of composition, the photographer must be able to recognize real and implied lines within the photograph. A real line is one that is obvious—a horizon, for example. An implied line is one that is not as obvious—for example, the curve of the wrist or the bend of an arm is an implied line.

Real lines should not intersect the photograph at the halfway point. This actually splits the composition in two. It is better to locate real lines (either vertical or horizontal) at a point that is one-third into the photograph, thus providing visual "weight" to the image.

Implied lines should not contradict the direction or emphasis of the composition but should modify it. These lines should be gentle, not

dramatic changes in direction, and again, they should lead to the main point of interest—either the eyes or the face.

Lines, real or implied, that meet the edge of the photograph should lead the eye into the scene and not out of it, and they pull the viewer's eyes in toward the center of interest, like the eyes, for instance.

Tension and Balance. Once you begin to recognize real and implied lines in your scenes and subjects and to incorporate shapes and curves into your portraits, you need to start employing tension and balance. Tension is a state of imbalance in an image—a big sky and a small subject, for example. Balance is where two items, which may be dissimilar in shape, create a harmony in the photograph because they are of more or less equal visual strength. Although tension does not have to

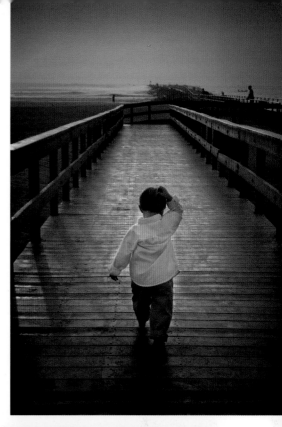

BELOW: Jerry D created this beautiful portrait that features parallel S curves within the composition. The line of the shawl or veil and the line of the young girl's pose mimic one another. The swirl of her hair is yet a third S shape. **RIGHT:** This beautiful portrait of a young barefoot boy by Jeff Hawkins employs a pyramid shape that draws your eye in to the image and back out to the boy. The detail and soft highlights on each board of the boardwalk add further interest and the pose, with the little boy scratching his head, is perfect.

LEFT: When you have more than one subject separated by a large space, you must "connect" them to make a cohesive portrait. Here, Ira and Sandy Ellis connected the two girls by using a strong diagonal line, which starts with the upper girl's arm and extends down to the second girl. Your eye does not stray far from the two main centers of visual interest. Ira used Photoshop to create the beautiful mirror reflection of the lower girl. **BELOW:** Tammy Loya has a beautiful 6' x 6' north-light window that she uses all year long. In photographing these three brothers, Tammy suddenly realized that the portrait was of their feet—a beautifully asymmetrical line that your eye follows from one foot to the next. To create a sense of drama and balance, the top of the image was darkened in printing. Tammy titled this image, *Little Piggies*.

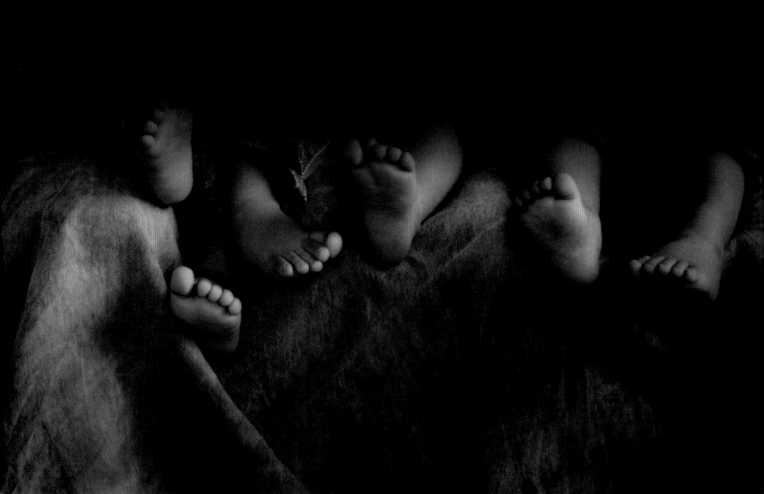

Anthony Cava produced this boldly graphic image that incorporates receding lines that are mimicked throughout the composition. The repeating pattern is broken by the little girl's shape, illuminated by the setting sun. The combination of repeating lines and an irregular shape creates a heightened sense of tension and balance within the composition.

be "resolved" in an image, it works together with the concept of balance so that in any given image there are elements that produce visual tension and elements that produce visual balance.

Tension can be referred to as visual contrast. For example, a group of four children on one side of an image and a pony on the other side of the image produce visual tension. They contrast each other because they are different sizes and not at all similar in shapes. But the photograph may be in a state of perfect visual balance by virtue of what falls between these two groups or for some other reason. For instance,

using the same example, these two different groups could be resolved visually if the larger group, the children, is wearing bright clothes and the pony is dark colored. The eye then sees the two units as equal— one demanding attention by virtue of size, the other gaining attention by virtue of brightness.

These terms are subjective but the eye/brain reacts favorably to both balance and visual tension and they are active ingredients in great portraiture.

Posing for Babies and Small Children

*A*lthough this is a book concerning fine portraiture, there is really no point in going into the various formal posing rules and procedures used for adults. They simply don't apply since, even if a two year old could achieve a proper head-and-neck axis, the likelihood of him holding the pose for more than a nanosecond is doubtful. Since little ones are mostly nonverbal,

posing instructions are completely ineffective. So then, how does one pose children—especially babies and small children?

When photographing small children and babies, you really need to have an assistant and some props handy to attract their attention. Whether the assistant is down at eye level with the child or behind the camera is strictly up to you—use whatever method works best. Small stuffed animals, small rocking chairs and carriages are all good props that can be used to keep the attention of the child and to set an appropriate mood. While your assistant is distracting and amusing the child, you can concentrate on other elements of the photograph—the lighting, composition and background.

With small children or infants, safety is always the first consideration. A child who cannot sit up by him- or herself cannot be "propped" up in a chair or left alone on posing

Posing babies when they're asleep is only slightly less difficult than when they're awake. In this beautiful portrait by Ira and Sandy Ellis, the composition and arrangement of the basket, blanket and flowers perfectly frame this angelic baby. Notice the beautiful highlight gradation and detail throughout the baby's skin.

blocks. He or she should be positioned on the floor or ground, with pillows or other soft supports nearby. The child should never be left unattended; if necessary, the parent should be close by.

It is important for the camera to be lowered so that you can relate to the child on his or her own level. Psychologically, this is important. Instead of leering over a small child with strange and unfamiliar equip-ment and funny-looking lights, you are experiencing the world from the child's point of view, making you an equal of sorts.

It is important to let children do what comes naturally. Amuse them, be silly, offer them a toy or something that attracts their attention, but do so with a minimum of direction. Kids will become uncooperative if they feel they are being over-manipulated. Make a game out of it

Here's another basket pose. This time, an older baby is the subject. Frances Litman created this wonderful image by waiting until the baby was alert and intrigued. This baby is able to hold himself up, which makes posing easier. A basket filled with soft blankets makes it more comfortable for him. Frances used a single softbox and a reflector that was angled from behind to act like a hair light.

so that the child is as natural and comfortable as possible. Generate a smile, but don't ask them to smile. If you do, you will probably not get what you want.

☐ INFANTS

Baby Poses. Posing babies is less tedious than you might think. Always consider the baby's safety first. Never pose an infant in a seat or on a support from which he or she can fall. Secondly, always have an assistant and/or the parent nearby. If Mom is there, her first priority will be the baby and she will always have one eye on the child.

A baby can be photographed lying on the bed with pillows all around. Pillows can be used for sup-

LEFT: This is really a family portrait of a father, mother and baby. Tammy Loya delicately composed all the elements so that the baby was safely intertwined within all those arms while he nursed. This is an award-winning image. **BELOW:** Anthony Cava made this beautiful angel portrait of a baby sleeping on his tummy. When photographing infants, it's either pose them on their backs or on their tummies.

port and to prop baby up exactly how you want him (or her). Another good pose is "on the tummy"—this is a pose most babies can easily adopt. If baby can hold his or her head up, he or she will usually do so as it provides a better vantage point. They will often kick their feet when in this pose. Even as children get older, the on-the-tummy pose still works well, as kids will rest comfortably with their head on their hands.

As mentioned, it's a very good idea to have Mom nearby—usually just out of frame. Infants will sometimes stay put, but other times they will crawl off and have to be brought back. Having Mommy close at hand makes things much easier, and it also gives the baby some reassurance in a strange environment. Mom or Dad can also help the photographer evoke special emotions and expressions. The photographer can say to

This is a wonderful infant portrait created by Robert Love. Here a mother and father are tenderly holding their baby, but Robert chose to include only their smiles in the composition. The viewer's eye goes back and forth between the smiles and the baby. This portrait has great balance and rhythm.

the child, "Look at Daddy, isn't he silly?" This is Dad's cue to act goofy or in some way amuse the child.

Another pose that works well with infants is to photograph them on their backs in their cribs. They are surrounded by familiar items, sights and smells and are easily photographed. There is often enough available light to make nice portraits, or you can use bounce flash or a flash with umbrella.

People who don't have happy faces aren't often successful as children's photographers. One technique that is often used is to prefocus the tripod-mounted camera and, with a cable release in hand, get

close to the baby and make cooing or kissing sounds. It really doesn't matter what sound you make as long as it's soft and gentle. Once the baby focuses his or her attention on you, you'll get some very good expressions. If the camera is motor-driven, you'll be able to stay in position and

get a series of good frames before the baby loses interest.

Mother and Baby. Babies, particularly at early stages in their devel-

TOP LEFT: This baby is obviously amused by the antics of Ira and Sandy Ellis while making her picture. One must know how to act like a little kid to get great children's portraits. The Ellis team will use silly voices and every type of squeaky toy known. Notice too that the little girl is posed in the tripod pose, in which one leg is bent to provide better support. Ira and Sandy made sure you could see all ten toes. **TOP RIGHT:** There is nothing quite so appealing as showing the love between a mother and baby. Here, Brian Shindle created this wonderful portrait in which he allowed the sleeping infant to receive all of the key light, while the mother's hair hid her most of her face, making her secondary to the baby in the image. Diffusion was used to give the image a dreamlike quality. **BOTTOM:** Monte Zucker made this wonderful composition of Mother and Baby. Baby's legs are being held (outside the frame) so that he can safely stay on Mom's back. The hands of Mother and Baby form a perfect "bracket" to contain the composition and the matching diagonal lines of their eyes also makes a beautiful image. But perhaps the best aspect of this portrait is the priceless expressions.

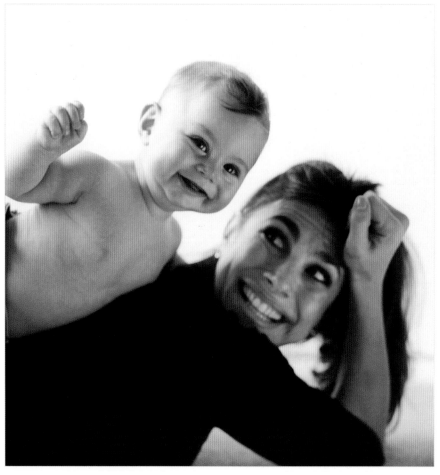

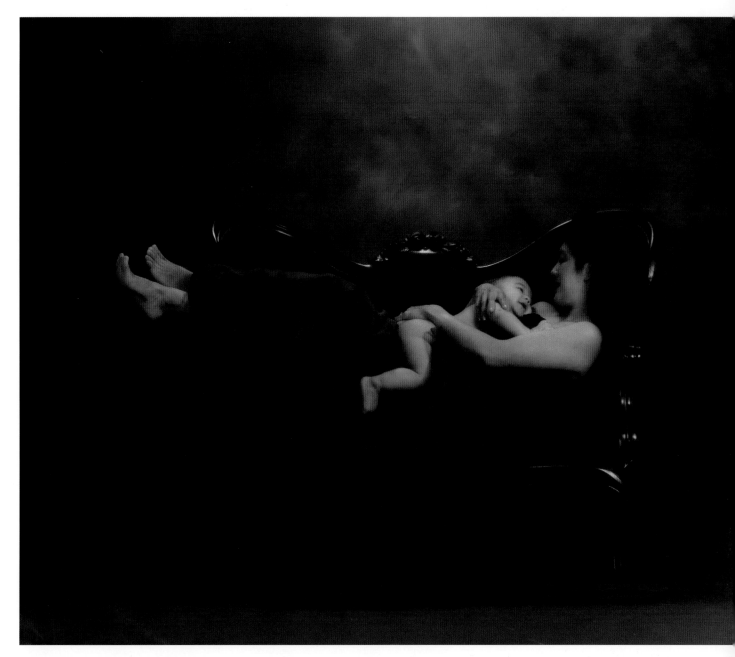

Even though this is a long and graceful image, the focal point is the "connection" between the mother and baby as they stare at each other lovingly. Rita Loy created this lovely portrait and used the highlighted edge of the love seat to create flowing lines within the composition. An element of humor is derived from the mom's feet showing at the end of the love seat.

opment, are inseparable from their mothers. If Mom is always holding her baby, you can assume there is an unusually strong bond between them. What happens when you want to "remove" Baby from Mother to make the portrait? Baby will not normally react well.

To avoid this situation, you can make some beautiful close-up portraits of the baby without Mom ever having to hand the child over. You can have the mom lie down on the floor with the baby next to her.

There is no feeling of detachment since Mom is nearby (just position the mother slightly out of frame). If she is like most moms, she can rest the baby on her hip and lean away, giving you a clear vantage point for a head-and-shoulders portrait of the baby, who is very happy to still be with his or her mother. There are

many variations of this pose and, since the baby will move wherever you tell the mother to move, you can pose the child with precision. Try to include the baby's hands in the photo, which can be easily done by giving the child something interesting to hold on to. Hands more completely define a baby portrait.

Up Close. Babies produce an extraordinary range of expressions. Sometimes, by zooming in with an 80–200mm lens, for example, you can fill the frame with the baby's face and if he or she is not being too wiggly, you can elicit a dozen completely different facial expressions. A series like this makes a beautiful sequence or montage. Be careful not to loom over the baby with too short a focal length lens, or you will resemble a Cyclops to him.

□ **TODDLERS AND SMALL CHILDREN**

Two Year Olds. When two year olds are involved, even the best laid plans rarely work out. You have to be flexible and open to following them around. For that reason, don't compose an overly tight set in which to photograph the child. Two year olds will do whatever they want. They are experiencing mobility (walking around) and the beginnings of speech (getting what they want by asking for it), and this leads to an independence that causes them to be known as "terrible twos." A loosely structured set in which they have some mobility (or better yet, an outdoor scene where they have a lot of

mobility) is recommended. You can, of course, with good communication and patience, direct the headstrong two year old—but not for long.

When working with two year olds, it is best to handhold the camera and follow them as they move around. This will often require shooting a lot of film and it may

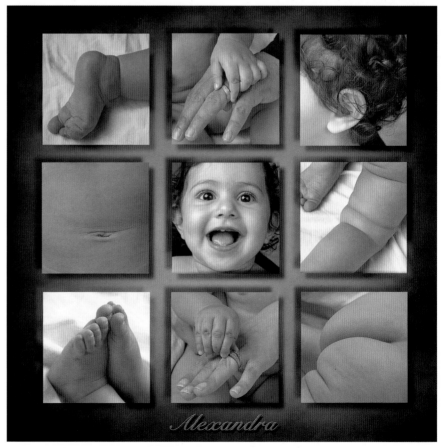

Alexandra

TOP: Rita Loy created this beautiful close-up of a mother and baby that shows the love, compassion and a beautiful bond between them. Notice how elegantly Rita poses the mother's hand. **BOTTOM:** Ira and Sandy Ellis offer this product, called "Baby Parts" to their clients. It is a series of close-ups of the baby's hands and feet, usually with a full-face close-up portrait in the middle. They say it's a huge success. The montage is assembled in Photoshop by bringing images into a template and reworking the type elements.

inhibit your lighting setup. Available light is often best with these active subjects.

Touching. Sometimes no matter how simply you explain what you want the child to do, he or she just doesn't understand your instructions. The best way to remedy the pose is to gently touch the child and move the errant curl or slide them over just a bit on the posing block—whatever it happens to be. Be advised that touching can be intimidating to children, particularly since you are a stranger. Always ask first and then be gentle and explain what you are doing. If the child is shy have Mom or Dad move the child per your directions.

Posing Steps. Many children's portrait photographers maintain several sets of portable posing steps or blocks that can be used individually or in tandem for several children. These items are usually made of wood and can be draped with fabric such as crushable backgrounds. Steps or blocks provide good support and are safe for toddlers on up. They will also work well for photographing more than one child at a time because they instantly get the faces on different levels—a must for good composition.

You can drape and position these items before the child arrives so that once the lighting is set you can bring the child over and he or she will sit naturally and fall into a normal, believable pose. A great advantage to using posing blocks in the studio is that they are large enough to conceal a background light placed behind them.

Facial Analysis. The minute any good photographer meets a client he

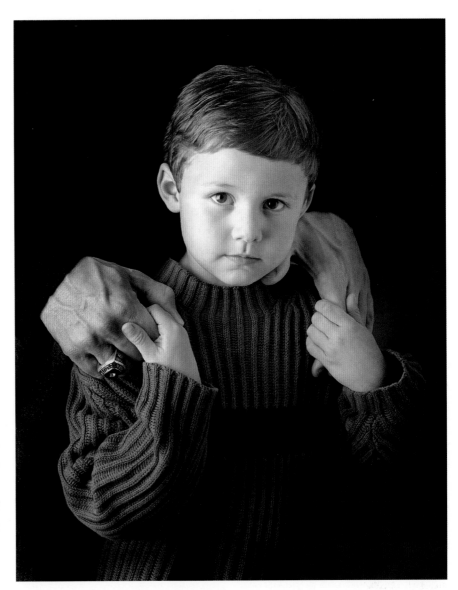

or she begins to make mental notes as to which side of the face they want to photograph, any irregularities (like one eye smaller than the other), facial shape (round, elliptical, elongated), color of the eyes, posture and so on. When they meet the parents and child they will be photographing, they are already formulating posing and lighting strategies. They will also decide whether the majority of frames will be close-up, three-quarters or full-length shots.

Most babies are blessed with flawless skin and hair, even though their tresses may be a bit sparse at first. And depending on how the child

Don Emmerich created this touching father and son portrait by having the boy hold on to Dad's hands, giving the young man a sense of confidence and self-assurance that is communicated in the portrait. Don lit the portrait for both the boy and the dad's hands.

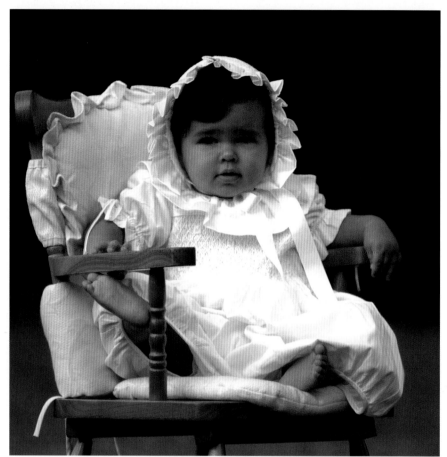

was born (i.e., either natural child-birth or Caesarean), the child may have an elliptically shaped head. But just as with adults, there are a vast number of differences between babies. Features to analyze are the cheekbones, the size of the eyes, a cleft in the chin, the depth of the furrow right below the nose (some-times called the Cupid's bow), the size and shape of the ears and nose, and so on. The expert photographer will catalog these features and devise a strategy to best light, pose and photograph the child.

The Turn of the Head. Typi-cally, when you ask adults to "Look here," their heads will turn only so far and their eyes will travel the rest of the way. With children, this is not necessarily the most attractive pose, because too much of the white of the eyes is visible. To get the eyes to follow the line of the nose when you hold something up for a child to see, you might have to move it back and forth slightly, so that their gaze fol-lows the object. When their eyes are facing straight ahead (on the same axis as their nose), you will have a more pleasing pose.

Sitting Pose. A good pose for small children is to have them sit up and curl one leg under the other. It makes them into a human tripod—very stable and upright. Children are

comfortable in this pose and have the full use of both hands so that they can hold or play with a toy or a prop you may have given them. And they usually don't wander off from this pose, unless they're very active.

Chairs. Small children may often do better when "contained." For this reason, little chairs make great posing devices. Place a tiny pillow in the chair and then have Mom place the child in the chair. When all is set, the photographer can cue the mom to call the child by name.

Adult-size chairs are also effective posing tools. The chair should be stable and visually interesting. A great pose is to have a child stand in the chair, holding onto the chair back and looking back over a shoul-der at the camera. Have a parent or assistant nearby in case the child gets too adventurous. Antique, stuffed or

ABOVE LEFT: Norman Phillips made this image of a bigger baby who was very proud of his newfound mobility. The dictionary must have started out as a different kind of prop, but allowed the baby something to climb onto and produced this priceless expression. **ABOVE RIGHT:** A baby chair is an ideal pos-ing tool. Here, Jeff Hawkins photographed this lovely girl in her favorite chair and her fanciest outfit. Notice how she uses her feet to keep herself stable and upright. **FACING PAGE:** Ira and Sandy Ellis had to make this fairy portrait through trickery and deceit. Apparently, the twins (left and right) could not look at Ira without screaming, so Sandy had to take over. To be on the safe side, she had them look at something on the floor to keep their eyes down (and away from Ira).

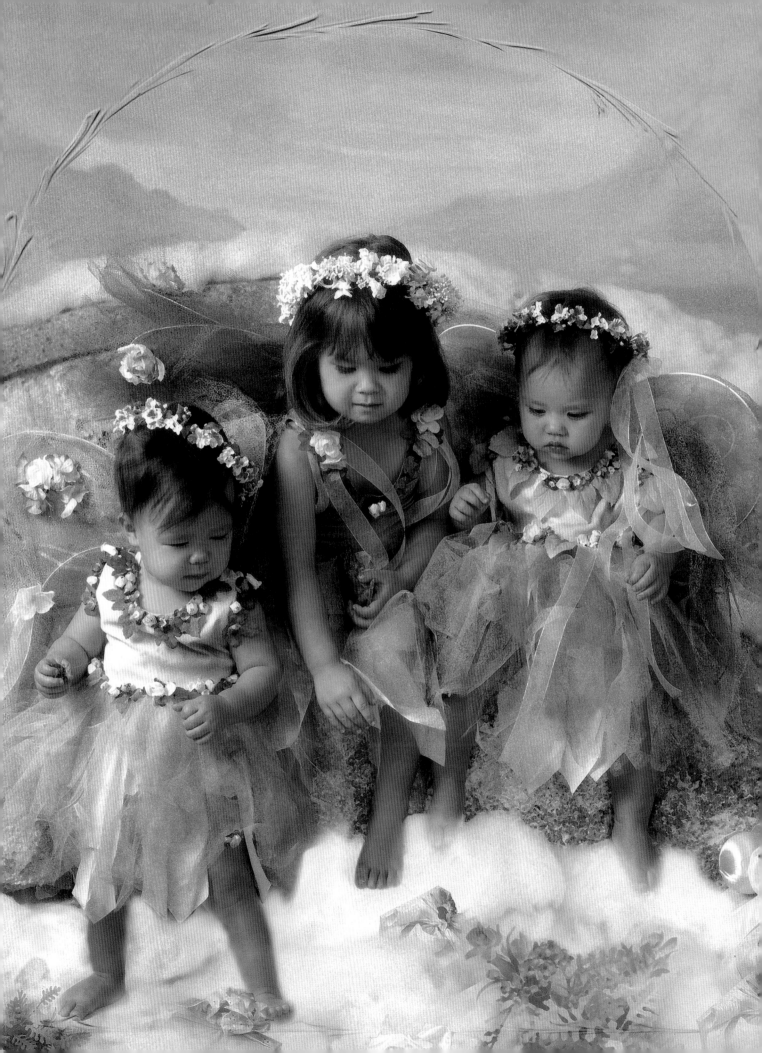

velvet chairs work beautifully for this kind of photo.

Activity-Centered Poses. Where little ones are concerned, posing really means maneuvering the child into a position in which he or she appears normal and natural. Little children react most positively to the concept of "activity-centered" portraits. In a typical shooting session, the assistant gets down on the ground with the child, just out of view of the camera. A full complement of props is on hand, including a bubble bottle and wand, a long wispy feather, a squeaker and a storybook or two. When the photographer decides the lighting and other technical details are right, the assistant will begin to coax and entertain the child. A long feather is a big hit and a great icebreaker. The feather provides both visual and tactile stimulation. Most children are fascinated and their expressions might range from curiosity to glee.

A good assistant will not bring out more than one item at a time to avoid overstimulating the child. He or she will use the props when needed, but the one that usually gets the biggest grins is the bubble bottle. Usually a single bubble floating at close range is enough to send the small child into a state of euphoria. A series of good exposures can be had with a single bubble—and if the bubble happens to wander into the frame, it's not a great loss.

A good assistant will know how to stimulate a child without overstimulating. Very often instead of bubbles and feathers, it is prudent to bring out a children's book—maybe even one of the child's own books that mother or father has brought from home. Sometimes small puzzles will thoroughly engross a child. There are many different ways to stimulate a child but you only have a window of about thirty minutes in which to get the pictures. To overstimulate too soon may end the session prematurely.

As the photographer and assistant gain experience working together, they will begin to anticipate each other's needs and the assistant will coax the smiles and giggles and lead to a crescendo before backing off—slowing things down. The photographer too will have to be patient and wait for the image to develop to the precise moment.

Stimulation. All children need stimulation in order to get good photogenic expressions. This is especially true for younger children, who need more stimulation than four and five year olds. You can stimulate little kids in a number of ways—by talking, imagining (playing make-believe), being silly, making noise, giving them something to hold on to and play with. With that same amount of stimulation, older children will end up getting overstimulated. Experience is always the best instructor, but generally more stimulation is required for younger children because their attention spans are so short. Remember that the end goal is to get great expressions, so use your energizing skills wisely.

Props and Games. Most children's photographers have a collection of props and toys for kids to play with. Mothers will probably bring a few of the child's favorite things too—a stuffed animal or a rattle or some other prized possession—and these can be used to

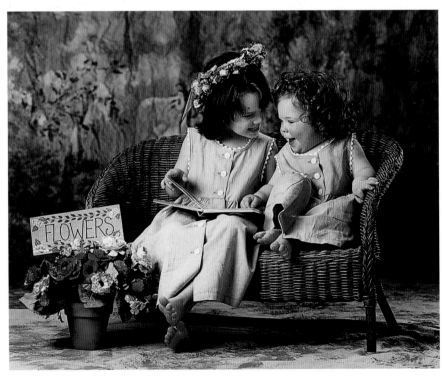

Frances Litman captured these delightful expressions by getting big sister to read to her baby sister from the storybook. Having excellent timing to catch these fleeting expressions is what separates the good children's portrait photographers from the great ones. (By the way, the flower pot seems to be a trademark prop that shows up in many of her portraits!)

Here's another basket pose. This time, an older child is the subject. Frances Litman made this charming portrait that could be a still life were it not for the little boy peering out of the basket. Getting a child to strike an animated pose may be as simple as a game of peek-a-boo.

attract and distract. Encourage parents to bring along items that will make the child feel comfortable and at home. This is usually not a problem with small children as they tend to "travel" with their favorite blanket or stuffed animal. Often a few flowers make wonderful props, since

small children are always fascinated by the color and shapes of flowers and enjoy holding something. Flowers can also add a little color and spice to your composition.

Usually it takes more than a prop to engage a child for the length of the photo session. Playing "make

believe" is a good option. Kids have a natural inquisitiveness that is easily tapped. Just start a sentence, "Imagine you're a . . ." Fill in the blank and you'll immediately see their imagination kick in!

Sometimes you just need to be silly with kids. Talk about your pet rhinoceros, or your other car, which is pink and yellow with purple seats. Texas portrait specialist Doug Box likes to ask kids, "Are you married?" which always gets a good chuckle. Peek-a-boo is another favorite—hide behind the camera and peek out from either side—the child will burst into laughter!

Above all, keep these sessions fun. Even if things don't go well, a child needs to perceive the experience as enjoyable and something that they'd like to do again. When Tammy Loya photographs children, she puts on

Nothing works like bubbles, as you can see in this portrait made by Norman Phillips. It's interesting to note the pile of "failed" props at the children's feet.

some "fun" shoes and usually a cartoon shirt. She is the true clown whom children all love. She even has a squeaky hammer, which she'll use to bop herself on the head. Sometimes she'll pretend she has a cold and sneeze loudly.

Communication. With older children the best way to elicit a natural pose is simply to talk to them. Kids are totally uninhibited and will talk to you about anything under the sun. Good topics involve your surroundings, if you are working outdoors, for example. Or you can talk about them—their interests, brothers and sisters, pets, and so on.

While it is not necessary to talk all the time, be aware that silence can be a mood killer and may lead to self-consciousness. Try to pace the conversation so that you are both engaging and yet free to set up the technical details of the photo.

Kids like being treated like an equal. They don't like being talked down to and they value the truth. Many photographers are honest

about what they expect of the child and tell them what they want the child to do. Children are more perceptive than they are given credit for. Be honest and have fun. Get them involved in the process of making the picture. You can even ask them how they would like to be photographed—kids like to be asked their opinion and they might just come up with a great idea.

Some children are on the quiet side and any kind of wild, exaggerated behavior might send them screaming so perhaps a quiet story and some low-key talking are called for. With children, it is a good idea to size up personalities, just as you would with an adult. Tammy Loya will ask children about their favorite thing to do and watch their eyes smile when they start to think about their favorite activity. Tammy will also make up stories in which the child is the star.

Sometimes with shy children, it is a good idea to stay in the background and let the parent do all the work. Tell the parent what you want and let Mom or Dad direct their child. In these situations, you might want to use a longer lens and back off so that you are not part of the interaction.

Well-known portrait photographer Frank Frost thinks that kids are too sharp to have anything pulled over on them. He thinks that "being real" with children is a must because they'll figure you out in a minute. Before he starts a photo session, Frost gets down on the floor and visits with the child. He always uses an assistant because he doesn't see how it's possible to get great expressions from children and babies and handle

This beautiful formal portrait made by Ferdinand Neubauer took great communication with his young subject. The posing is traditional and refined. The costume is elegant. The lighting is soft and perfectly feathered to bring out delicate highlights and good modeling. This kind of painstaking detail takes time and good skills on the part of the photographer to keep his young subject involved and focused.

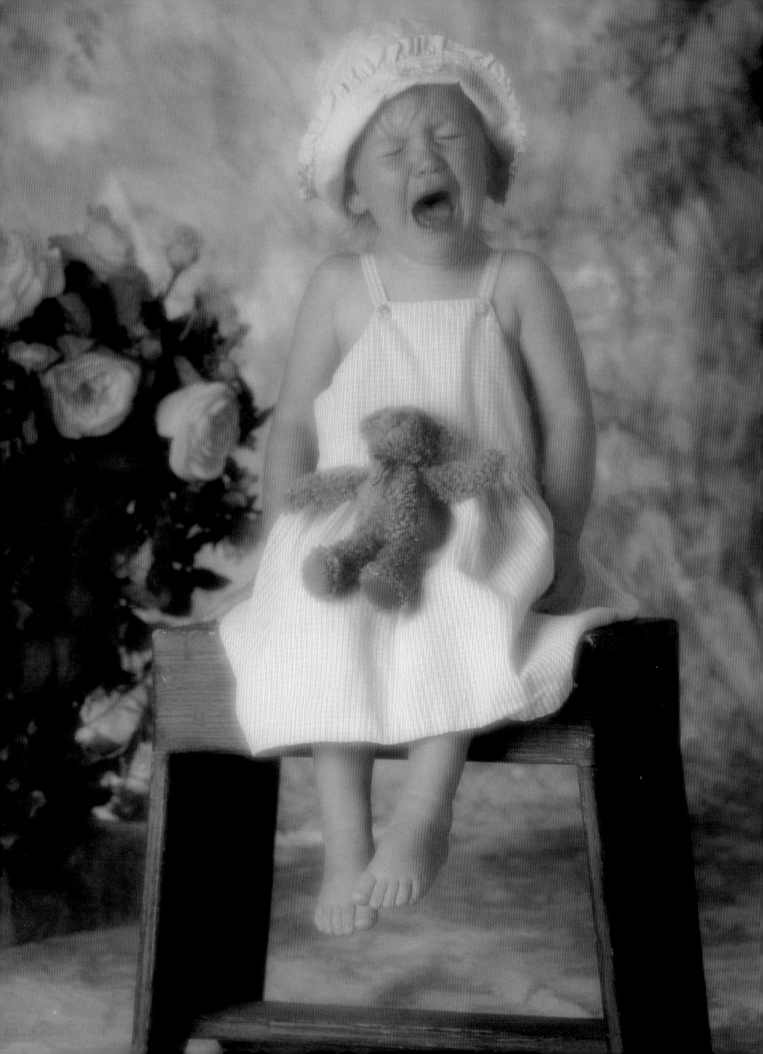

all of the technical details and posing. His assistant hams it up with the child while Frost readies the lights and camera. To make his studio a place children want to return to, he keeps a small toy box in the studio, which children always seem to remember fondly.

Eliciting Expressions. Kids will usually mimic your mood. If you are loud and boisterous, they will be too—if they are not shy or quiet by nature. If you are soft-spoken and kind, this too will rub off on them. If you want a soft, sweet expression, get it by speaking in soft, quiet tones. If you want a big smile, bring the enthusiasm level up a few notches. Above all, be enthusiastic about taking the child's portrait. The more he or she sees how fun and important this is to you, the more seriously the child will take the challenge.

Never tell children to "smile." Instead, ask them to repeat a funny word, or ask them their favorite flavor of ice cream. And don't be afraid to create a more "serious" portrait— the best expressions aren't just the big smiles. Many parents prefer a mix of smiling and more natural poses; it's always advisable to ask the parent what they expect to see, but use your intuition. A mix of portraits—a few with smiles and some

FACING PAGE: Sometimes the best laid plans . . . This portrait by Frances Litman had all the makings of a beautiful portrait. We're not sure what went wrong, but this was the best image made during the session. **RIGHT:** Award-winning photographer Travis Hill captured a shot of this giggling subject as she poked her head out from behind a column. Small children love games and catch on quickly.

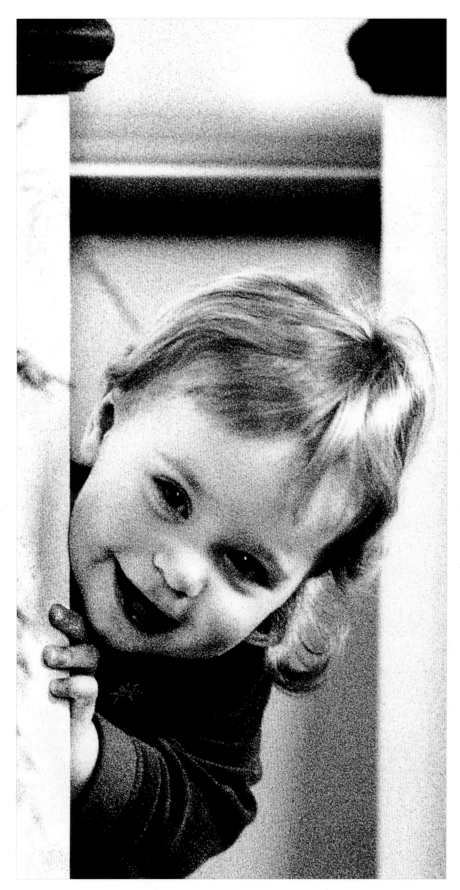

This is a great example of what a classic photograph is all about. In the words of the photographer, Gigi Clark, "I shot this photo in the beginning of my career and it still shines. I was documenting a still life on the wall of an ice cream parlor when I noticed a five-year-old boy gazing at me. I immediately pivoted the camera on my tripod and recorded him, my light readings previously set. In the world of children's photography, one must be at the ready to observe and document these moments, much like a photojournalist. Jeremy was not posed, but merely captured at the right place and the right time."

showing the child's gentler side—is always appealing to parents.

Don't underestimate the power of positive energy. After a few frames tell the child how handsome or beautiful he or she looks and let the child know how things are going. Like all people, children love to be told they are doing a good job.

Work Quickly. With kids, especially small children, you don't have much time to work, so be sure your lights and background are roughly set before bringing the child into the studio or into the area where you're going to make the photograph. You have about thirty minutes in which to work before the child gets tired or bored or both. You need to work quickly and this is another reason to have an assistant who can hand you a freshly loaded camera or magazine, adjust a light or the fold of a blanket without you having to move from the camera position. Always be ready to make a picture, since children's expressions are often fleeting.

Many expert children's portrait photographers work with a camera on a tripod and a long cable release. This frees them from the camera position, allowing better interaction with the child. In such situations the composition must be a bit loose, in case the child moves. Also, observe the child's movement when focusing, to get an idea of where your focus point should be and how far your depth of field extends within the scene. Take your best estimate on focus, with the certainty that you'll have enough depth of field, even if the child moves, to get a sharp image. Working one on one with the child is preferable to talking to the child from behind the camera.

This last piece of advice may seem contradictory at first: You cannot rush a good portrait. The difference between average and great is often in the details. You have to spend the time laying the groundwork for a good portrait—spending time with

the child so he or she trusts you, letting the child acclimate to these strange surroundings. It would be foolhardy to rush and end up getting nothing noteworthy for your efforts. In this environment where the best conceived portrait can be wiped out in moments by a mood swing, the best you can do is to sharpen your reflexes and timing with the knowledge that you many only get one chance to make the portrait.

Timing. When working with strobes, which have preset recycle times, you cannot shoot as you would under available light—one frame after another. You have to factor in at least these two things: (1)

This lovely image by Gigi Clark was taken near the end of the session, when she noticed the little girl was interacting with the family cat. Instinctively, with a gentle prompt, Gigi asked if she could "go nose to nose" with the cat. The result was purely whimsical.

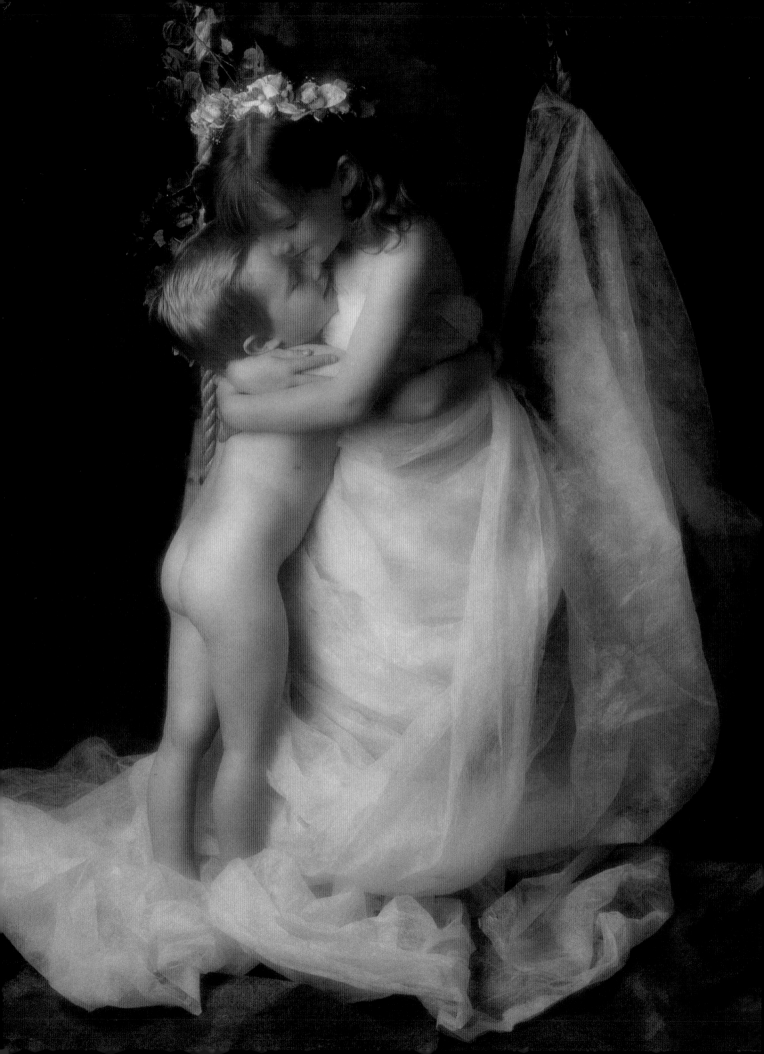

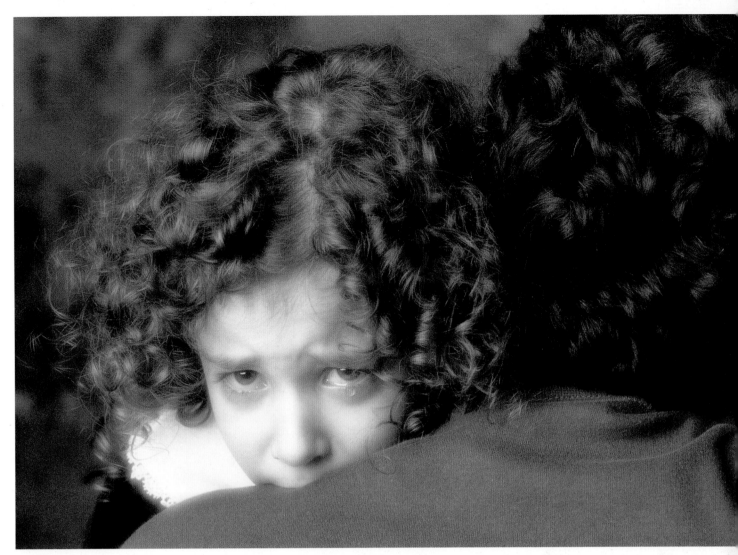

FACING PAGE: This portrait by Frances Litman started out as a portrait of the young girl wrapped in flowing chiffon on a swing. Somehow her little brother appeared on the scene and the image turned into a different picture. Reacting quickly to the change made this beautiful picture a reality. **ABOVE:** Here's another example of a picture that changed midstream. Frances Litman was photographing the young girl in her beautiful outfit when something happened. When Dad stepped in to give her a hug, Frances made this wonderful image.

the strobes may startle the child initially, thus curtailing a fun time; and (2) while you're waiting for the flash to recycle you may see three or four pictures better than the one you just took. Experience and patience are keys in the latter situation; you don't necessarily have to jump at the first opportunity to make an exposure. Here's where working with a trusted assistant can really help, since you can gauge by their activity if the event is building or subsiding. Out of every sequence of possible pictures one will be the best. Assume you'll only get one chance and your patience will often be rewarded. Perhaps the best advice is to always

be ready. Preparedness often leads to success.

The Bribe. Many of the top children's portrait specialists will resort to the common bribe to keep a small child interested in the session for "just a few more shots." Some photographers will use a reward system whereby they give the child a coloring book or other small gift for being such a good subject. Other well known children's photographers offer cookies midway through a session as a means of keeping a little one's interest. (Remember to get permission from a parent before doling out food!)

Clothing

Clothing is really the best form of "prop" for a child's portrait. Fine clothing, like a christening gown, can define the moment—or it can define personality—like jeans and a cowboy shirt. Clothing makes the difference between upscale and average.

Portrait photographers Brian and Judith Shindle believe in the upscale prop. Brian recently purchased a christening gown from Nieman Marcus for $1500. It is the Shindles' way of enhancing the timeless quality of the child's portrait. Not only is the portrait elegant, but using something unique like the christening gown, sparingly, can also enrich the portrait experience from the client's

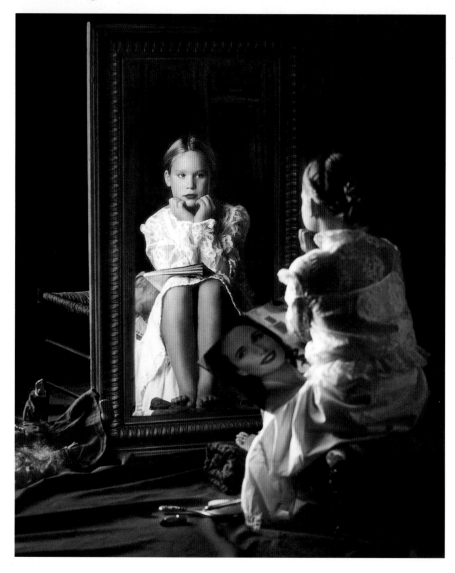

Tammy Loya created this award-winning reenactment of Norman Rockwell's *Girl at Mirror* (1954), an illustration for the *Saturday Evening Post*. Tammy's image is called *A Rockwell Moment*. This kind of portrait takes amazing patience and planning. Details like the ad in the magazine and the doll thrown on the floor (symbolizing the girl's cast away childhood) are handled in perfect detail. Tammy used bi-fold doors as a background and additional bi-folds to reflect in the mirror and hide her studio. Using natural light from her 6' x 6' north light window, the exposure was one second at f/8. She used a Mamiya RZ 67 with a 180mm lens, cable release and the camera's mirror locked up.

perspective, making the session more gratifying. However, such elegance is not without risks. Every time Brian takes the gown out of its special bag, he hopes his little client won't throw up all over it.

There are classic little boy outfits and classic little girl outfits, which define not only their gender but also say something unique about the child. Their best clothes are always handpicked lovingly by Mom and the children adapt an air of confidence when they are dressed in "Mom's favorite" clothes. There is something beautiful and memorable about a crisply dressed child with his or her hair combed neatly and dressed in their finest clothes. It's special for the parents and the children and it usually doesn't happen very often. Keep in mind, though, that very little children can sometimes get lost in their clothes and sometimes it is appealing to show a little skin—arms, legs and most definitely hands.

□ **CONSULTATION MEETING**
Clothing should be discussed and coordinated during a pre-session meeting. All of the specific items for the shoot should be coordinated with the clothing, so that props like blankets and stuffed animals have colors that complement one another. When photographing children outdoors, it is important to dress them in clothing that is appropriate to the setting and the season. For example, if the photo is going to be made in an elegant wood dining room, don't arrange for the child to wear shorts and sneakers. A child's portrait is meant to be enjoyed for generations to come. Fad-type clothing should

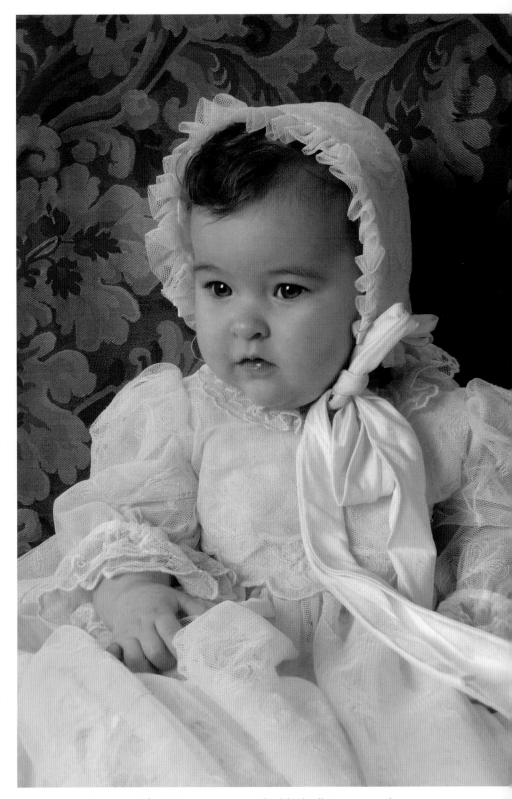

Here's a beautiful portrait of a little one in Brian and Judith Shindle's outrageously expensive christening dress.

be avoided in favor of less trendy, more conservative dress.

Arrange for the parents to bring more than one outfit. At least one outfit should be all solid colors without designs. If more than one child is being photographed, brother and sister for instance, clothing should be complementary or matching colors. Gaudy designs and T-shirts with writing—or worse, cartoon characters—should be avoided. Also, the child's new clothes may not necessarily be comfortable. An alternative is to bring both casual and dressy outfits. Start the session with the child in casual, familiar clothes and work up to the dressy outfit.

Acclaimed portrait and wedding photographer Monte Zucker created a document that he sends to clients who have booked an appointment. He emphasizes that the selection of clothing is critical in the preparation for a successful portrait. If the clothing is noticeable in a portrait, it could easily become a distraction. Clothing that does not attract attention to itself is the desired goal. It could be the difference between a very successful portrait and just another picture. Monte even goes so far as to say, "It is quite possible that if inappropriate clothing is selected, the photographer may ask you to change your selection before the portrait sitting is made."

People don't realize that the wrong selection of clothes can ruin the photograph. That is why it is so important to discuss this prior to the session. Having to reshoot the portrait is costly and inefficient for both the customer and the photographer. Below are several topics that should be covered in the consultation.

ABOVE: There is nothing quite as handsome as a young person crisply dressed in his or her finest clothes. In this outdoor portrait by Ira Ellis, the young man's choice of clothing is excellent for bringing out his nature and personality. Shoes can sometimes date a portrait, but Ira has done a nice job of hiding the foot in shadow. **FACING PAGE:** This award-winning print by Tammy Loya, is entitled *Attitude*. The little girl is dressed in her finest dress and posed in a white wicker chair, but her expression is introspective. The print was darkened at the corners and a texture added to the background and part of the dress in the foreground.

Dark and Light Colors. Darker clothing helps to blend the bodies with the background, so that the faces are the most important part of the photograph. As a general rule, dark colors slenderize the subject while light colors seem to add weight to the bodies. While this point is usually not a factor with children, with some overweight or skinny children it could be.

The color of the clothing should always be toned down. Bright colors pull attention away from the face. Prints and patterns are a distraction and, in the case of digital portraits, small patterns (even small herringbone or checkered patterns) can cause unattractive moiré patterns to appear in the fabric.

Glasses. You see more and more children wearing eyeglasses these days. For the child's portrait, glasses may or may not be worn, depending on the parent's or the child's preference. Nonreflective lenses are help-

ful to the photographer, who will be restricted as to the lighting setup when eyeglasses are a part of the portrait. Sometimes it's possible to obtain a matching set of frames with no lenses. This is particularly helpful if the child's glasses distort the outline of his or her face.

Shoes. Shoes are often a problem on small children. The soles are usually ugly and they can sometimes dominate a portrait. Most frugal parents purchase shoes with the expectation that they will "still fit in a month," so they are often a little loose and look large. Some photographers, if the scene and clothing warrant it, will have the child remove his or her shoes. Children's feet can be quite cute.

Hats. Hats are often a blessing in disguise. The child will often feel right at home in his or her favorite hat or cap. Hats also add an element of uniqueness. When working outdoors in open shade, hats provide some overhead blocking of the diffused light—like little overhead gobos—and minimize the overhead light on the child's face. In the studio you must be careful to get light under the hat to illuminate the eyes.

Clothing for Groups. Often children will be the focal point for a family portrait. For a clean look, the color scheme for family portraits should be no more than two or three colors. In fact, the most beautiful family portraits are made when everyone is dressed the same—not in matching outfits, but all dressed in white or denim, for example. The clothing should be kept simple, so as not to distract from the faces.

ABOVE: Coordination is essential when photographing a family. Here, Bill McIntosh specified white tops and khaki pants, and you can see how well they blend together. Bill shot this portrait at twilight and underexposed the background by one stop. He used barebulb flash as his key light. **FACING PAGE:** Kimarie Richardson created this fantasy portrait. Notice how the girl's expression is consistent with the props and outfit. Her bare feet are cuter than any shoes could have been.

Noted portrait specialist Bill McIntosh is a master of the coordinated environment. He is a stickler about planning. "No matter how good your artistic and photographic skills are, there is one more element required to make a great portrait—color harmony." In McIntosh's photographs the style and color of the clothing are coordinated. He says, "I

have ensured these suit both the subjects and the environment." Bill makes sure that everything matches. "Time is well spent before the sitting discussing the style of clothing—formal or casual—and then advising the parents and family members of particular colors which they feel happy with and which would also create a harmonious portrait."

Solid color clothes, in cool or neutral shades, with long sleeves, always look good. Cool colors, such as blue and green recede. Warm colors, such as red, orange and yellow, advance. Cool colors or neutral colors (such as black, white, and gray) will emphasize the faces and make them appear warmer and more pleasing in the photographs.

Your groups' garments should blend. For example, all of the family-group members should wear informal or formal outfits. It is difficult to pose a group when some people are wearing suits and ties and others are wearing jeans and polo shirts. Shoe styles and colors should blend with the rest of a person's attire: dark outfits call for dark shoes and socks.

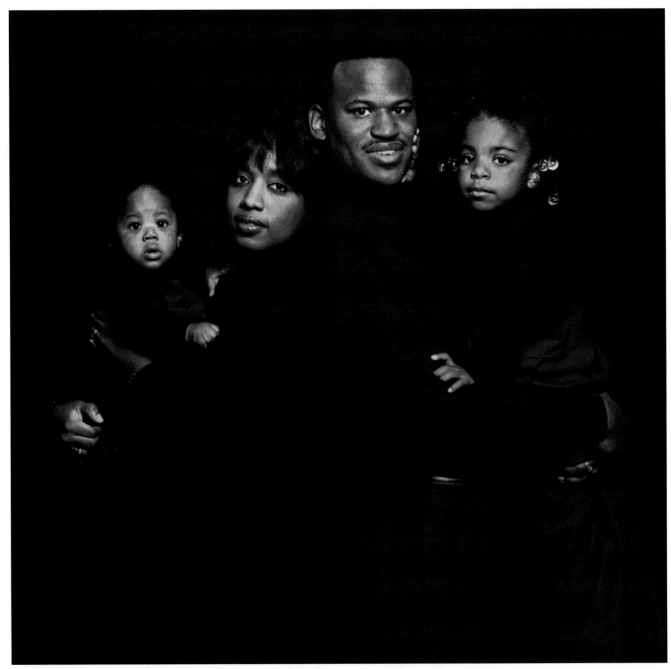

In this portrait by Gigi Clark, the order of the day was black outfits and a black background. The idea was to create an environment where each face stands out on its own but also fits in as part of the family. Notice how the photographer rendered the dark clothing with detail throughout, an aspect that further enhances the quality of the portrait.

Fantasy Portraits

A recent development in the world of children's portraiture is the children's fantasy portrait. These are highly imaginative images that call for elaborate props and costuming or elaborate post-capture manipulation. Producing these portraits is labor-intensive work that might require hours of work in Photoshop or other image-editing programs. These images are definitely on the high end of the portrait scale, and command higher-than-normal fees.

□ MARSHALL OILS

Some children's fantasy portraits begin as conventional images made on beautiful hand-painted backgrounds. This is the way Kimarie Richardson creates her Fantasy Stills. The image is first printed elegantly in black & white and then treated with hand-coloring oils (Marshall

Kimarie Richardson created this darling portrait from a black & white image, which was then hand-colored using Marshall Oils. Parts of the image were diffused in printing (the bottom of the image) to mask sharp details. Yellow was added to the curtains, and other coloring was added to the roses and foliage. But to preserve the fantasy element, the scene outside the window was preserved in black & white, although some of the flowers were painted in white tones. Even the baby's eyelashes were extended with small brushstrokes.

Oils) to bring a pastel effect to the image. Often, parts of the image are left black & white to preserve a portion of the original image and to heighten the illusion of the pastel oil treatment. Because these oils are transparent, image details are visible through the applied oils.

Areas of the image may be "worked" with the oils to bring in color and sometimes to alter the shape of existing forms in the photo. For instance a garland of flowers, pictured in the painted backdrop, may be colored and extended into a blank area of the photo. The mixture of photography and hand-made artwork is not new, but it lends a completely different feeling to the image.

□ PROPS AND CLOTHING

Other children's fantasy portraits involve dressing the kids up as fairies, mermaids, angels or other mythical characters. The "property departments" of many studios are brimming over with costumes, hats, veils, boas, feathers, angel wings and loose pieces of eccentrically colored fabric—cotton, linen, burlap, mesh, gauze and just about any exotic cloth you can think of! These fabrics are sometimes draped beneath or around the child in an effort to fash-

ion a costume. Sometimes these fabrics are loosely pinned to form a smock or gown, depending on the material.

Props might include logs, rocks or tree stumps (all artificial, lightweight and commercially available). These are used to build a "forest scene" or wooded glen, for example. The sets are also frequently garnished with artificial leaves, plants and flowers, which can be positioned

near and around the children. Small props, like woodland animals, frogs, butterflies, birds, and so on are also used to add to the illusion of the fantasy portrait. Small garlands of artificial flowers are often used as headbands. Garlands are also sometimes loosely arranged within the photograph as color accents.

A number of costumes are needed in order to create fantasy portraiture. These need to be loose-fitting so

Here is another hand-tinted masterpiece from Kimarie Richardson. The retouching in this image is less noticeable as the overall image has been reworked. Subtle details in the little girl's face and dress and the cat's mouth and fur have been changed and embellished. The effect is much like a painting, where highlights have tiny white brush strokes. The monochromatic feeling of the image has been preserved while adding subtle tones of blue and brown.

Amidst a hand-painted canvas background and white columns, Rita Loy positioned this baby and older sister. The image has been diffused and extensively retouched. But what makes this a fascinating image is the flow of the chiffon, used lavishly to create a dreamy cloud-like atmosphere. This portrait is beautifully and consistently propped but what makes it so wonderful is the connection between the two—they are holding hands and the eye contact forms a powerful diagonal line between their two faces.

that they can be adjusted to fit any size child. Fairies are a popular fantasy, so items that can enhance a basic costume are always valuable. Of course, there are also a wide variety of costumes commercially available from many sources. Small children are often photographed bare-footed so that the child's shoes don't spoil the illusion.

Sandy and Ira Ellis of Ellis Portrait Design offer such children's fantasy portraits. Their studio is stocked floor to ceiling with props for children's fantasies. For example, the small suitcase is a popular prop, used to create the illusion that the child is traveling to some exotic location. The Ellises have at least a dozen such suitcases. They also have two antique rocking horses and at least three antique tricycles, including one made of twigs and branches.

Some of the Ellises' props hang on the wall. Others are stacked on shelves and in storage bins. There are costumes galore, most very simply made. Some are gauze slip-ons that can be fitted over a child wearing a basic leotard or bodysuit. Then the costume is accessorized with garlands, a waist-belt or sash. Hats are always a big hit with kids and range from pointed wizard hats in bright colors to little sailor's hats. All the costumes and accessories need to be simple and loose-fitting, otherwise

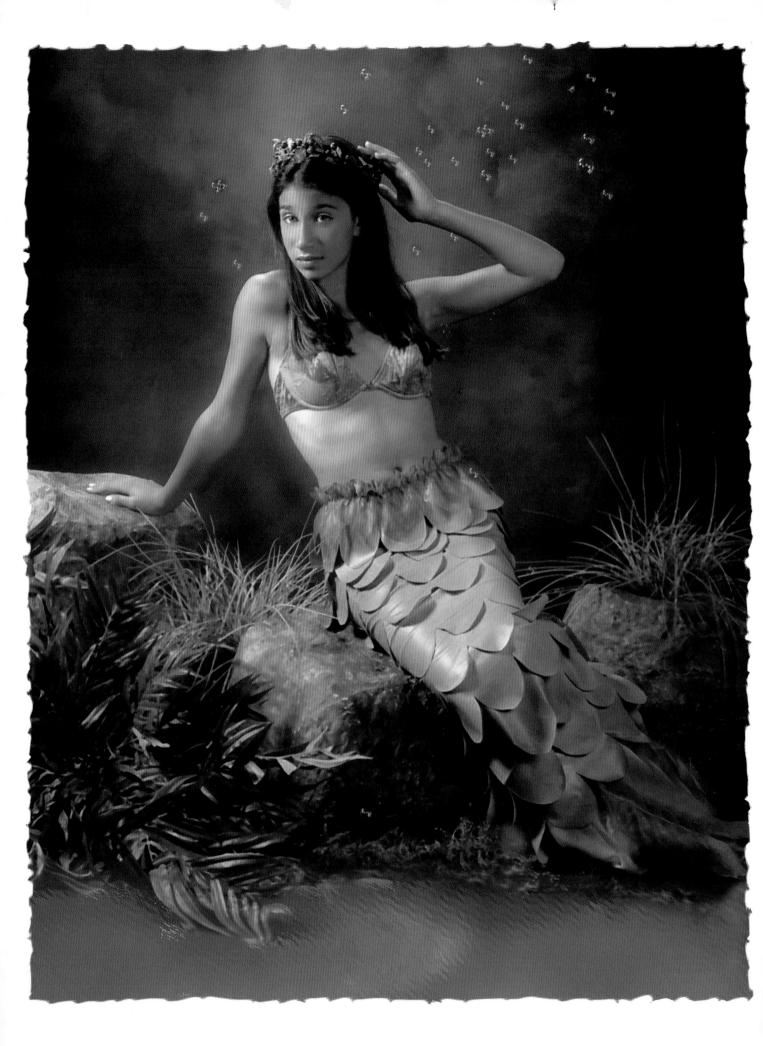

smaller children will feel too confined and uncomfortable.

□ BACKGROUNDS

Along with a wide range of props, costumes and accessories, the photographer offering this style of portrait must also have a wide range of hand-painted canvas backgrounds, which are available through many vendors. These backgrounds are usually done in pastels and can be either high key or low key in nature. Sometimes the details in these backgrounds are purposely blurred so they do not attain too much visual attention in the photo. These hand-painted backgrounds are often done in pastels and neutral tones so they complement brighter shades used in the costumes of the children.

Some photographers, not being able to find exactly what they want in commercial catalogs, hand-paint

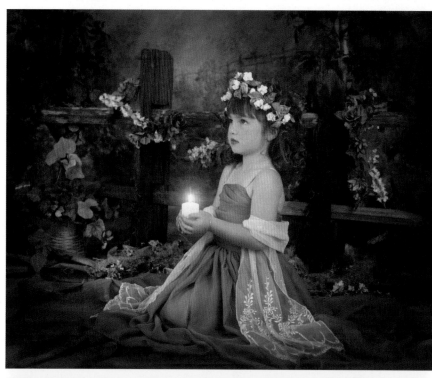

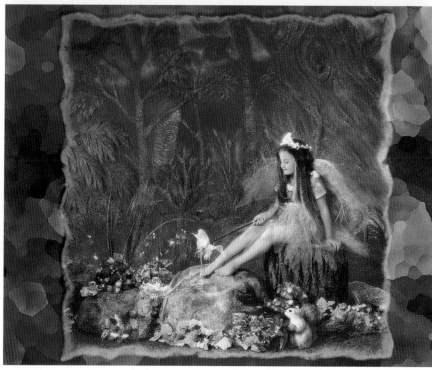

FACING PAGE: This is another Ira and Sandy Ellis image—an ambitious undertaking. The entire image is made to look as if the girl is underwater. Highlights and shadows are blended in Photoshop and sharp image details like the foliage and rocks are softened and blended. The reflections in the foreground were all created in Photoshop, as were the bubbles. Not merely an "effects" image, the lighting in this mermaid portrait is exquisite. **TOP LEFT:** Kimarie Richardson created this beautiful image by using the candle as a main light source. She exposed the image at ½ second on Kodak Portra 160NC film. In order to open up the image all over, a soft fill light was used to softly light the set. The photograph is exquisitely propped and the expression and posing are angelic. Kim's studio, by the way, is called Fantasy Stills. **BOTTOM LEFT:** Ira and Sandy Ellis create children's fantasy portraits for their clients on a regular basis. This image is richly detailed. All of the props you see—the flowers, the background, the rock and the log and all of her costuming appeared in the original photograph. The image was then scanned and brought into Photoshop where the details were brightened and embellished and some made to glow—like the tiara on the child. The image was then combined with a multi-colored background template and merged to create the final image.

Here before and after images are shown so that you can see how extensive modifications can be. The original image of the twins was in black & white with the mother, the nanny and the photographer all trying to keep the babies from rolling over or poking each other in the eye. The image of the twins was scanned and removed from the background and the babies were placed into a background of clouds in Photoshop. Hand-drawn angel wings were added in Photoshop as was a slight glow around the babies. The image was then printed on twenty-year-old art paper, and the entire image was pencil-colored using Prismacolor oil-based art pencils. The pencil-coloring is extensive in order to blend image details and color. The final result is a true blending of drawing and photography. Images by Shell Dominica Nigro.

their own backgrounds using acrylics and a thin gauge canvas. The thicker canvas backgrounds are on rolls, suspended out of view of the camera behind the subject. Others are soft muslin material and can be hung or draped in the background. There is even a "crushable" soft, cloth painted background that shows the many folds and wrinkles in the material. Such backgrounds catch highlights and shadows in the folds, creating a dappled look to the background.

□ PHOTOSHOP AND BEYOND

Most of the photographers offering fantasy children's portraits are well-versed in Photoshop or other image-editing software. Images are brought into the program and "worked" in any number of ways. Ira Ellis uses a series of Photoshop templates that he employs as sub-backgrounds. The primary portrait image is layered onto the template, which has rough and uneven edges and then positioned atop a background of com-

plementary or neutral tones, or often a textural image like sand. Usually a drop shadow is used to imply depth. The effect is very three-dimensional.

Photoshop gives the photographer the ability to embellish the fantasy portrait with almost infinite variation. Ira Ellis often adds new elements to the photograph, like bubbles or a pond with ripples. He might then mirror the portrait image in reflective surfaces to further refine the illusion. The image, already ornate, takes on a new dimension in

Photoshop. Areas of the image may be softened, other unique elements may be brought into the primary image or parts of the image may be altered to render them transparent. The sky is really the limit.

☐ MIXING MEDIA

Other photographers rely on the power of Photoshop and the artistic skills needed with colored pencils. While in Photoshop, hand-drawn elements, such as angel wings, may be added. Backgrounds, may be removed, and substitute background elements introduced. After the image is refined in Photoshop (which may in and of itself be a major undertaking), a large inkjet print is made—usually an 11" x 14" on an artist's paper, which is receptive to oils or Prismacolor oil-based pencils. The image may then be hand-colored or the colors enhanced or softened using the applied media. Pencils, in particular, are a means to redefine subtle highlights and shadows, mixing color with white to blend and soften or to make an area of the image glow. The final effect is like a sketched color photograph. Pencil lines are visible if you look closely enough. The image may then be rescanned so that multiple copies may be produced or the final image can be presented to the client as a one-of-a-kind original, which it is. Such images are often framed in ornate frames with mats that further enhance the illusion of the fantasy portrait.

It is important to note that no matter how imaginative the effect, the basics of a good children's portrait must still be present—good lighting, posing and expression.

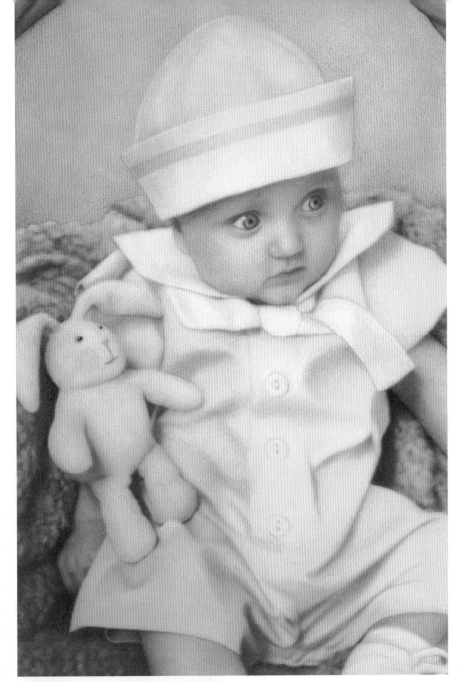

This image, entitled *Popeye*, started out black & white. The 8" x 10" contact sheet was scanned at 600 dpi and the individual image (1" x 1.5") shown here was selected, and then printed on 11" x 17" art paper. The extreme enlargement added to the image's overall softness. The entire digital print on art paper was then hand-colored using Prismacolor oil-based pencils. The eyes of the baby, already large, were especially enhanced and brightened in the hand-coloring process. Also the background, blanket and handle of the picnic basket were extensively "worked." Images by Shell Dominica Nigro.

Posing Older Children, Teens and Seniors

Posing older children requires a different mind-set than that used when working with small children and babies. Adolescents and high-school-aged kids require patience and respect. They also want to know the details—how long the session will take, what is involved, etc.

Many photographers who photograph this age group say that the best way to proceed is to tell young people that you will be making a series of images just for Mom and Dad, and then you'll make some images just for them.

Seniors are an age group in transition. These clients often have boyfriends or girlfriends and are thinking about college and about leaving home, all of which can make for a confusing time. A portrait made at this stage of their lives is a valuable heirloom because these young adults will never look or act quite like this again.

Experts advise making the photo session fun, but not in some phony way that the kids think is corny. Be

Senior sessions should reflect an activity that defines the young person. Here, Michael Ayers created a lovely portrait of this musician at the harp. Michael captured the intensity and enjoyment that this young girl derives from her music.

ABOVE: This is an award-winning image by Frank Frost. One of the connections seniors have to the adult world is their car. It may be a pile of junk but it is usually their prized possession and it is something about which they are keenly interested. Frank often uses a teen's car in a senior portrait because you can see the love when they show it off. This image was made by available light in late afternoon shade and the girl's floppy hat provided good direction to the light. The catchlights were worked on later in Photoshop. **LEFT:** Senior girls are really young women. They enjoy looking beautiful even though they may not feel that kind of self-confidence all the time. Frank Frost photographed this lovely senior, and you can see by the smile in her eyes that she is enjoying the session.

yourself, but be excited. Like all kids, they will react positively to your enthusiasm and positive energy as long as they feel it's genuine.

One of the differences between big kids and little kids is that the older ones think of themselves as individuals. They will often have unique clothes or hair (or tattoos or piercings) that set them apart. Instead of reacting negatively to their uniqueness, react with appreciation. If you earn their respect, they will be much more involved in the session.

Treat teens like adults and they will respond like adults, or will at least try to. Ask them about their lives, their hobbies, their likes and dislikes and try to get them to open up to you, which is not always easy. Some teens are introspective and moody and it will take all of your social skills to bring them out of their shells.

You may have to exercise a little less control over a senior setting. Teens want to feel that they have

RIGHT: When you have your consultation session with the young person tell him or her that it's okay to bring along a friend. Make use of the opportunity and you may get some wonderful images. Photograph by Frank Frost.

BELOW: Ira and Sandy Ellis offer senior fantasy sessions in the same way they offer them for younger children. This is a beautiful example of a senior portrait done in a European style. The young girl is posed gracefully and the lighting is exquisite. The black velvet dress makes her look glamorous beyond her years. When making such a dramatic portrait, the Ellises use lots of props and set decorations to make the portrait authentic.

When seniors bring a variety of outfits, there is invariably one that they think they look great in. It is usually casual—here, a T-shirt and jeans. Gary Fagan made this senior portrait at an outdoor alcove. He used a single shoot-through umbrella almost like a fashion light (head-on) so that there are almost no shadows.

control, particularly over their own image. You should suggest possibilities and, above all, provide reassurance and reinforcement that they look great.

□ NO PARENTS

Teens probably will not feel comfortable with a parent around. Instead, ask them to bring along a friend or two and photograph them together. Parents often make their teens feel self-conscious and awkward—the last thing you need when you make their portrait. You need to assure the parents that you have their best interests at heart and that you want to be able to provide them with a photograph that will make them happy and proud.

□ HIGH-END SENIOR STUDIOS

Senior portraits are usually done by the schools on picture day, but that is not the type of senior portraiture referred to here. Many studios have taken to offering high-end, very hip, upscale senior sittings that allow the kids to be photographed with their favorite things in their favorite locations. For instance, a senior's car, usually a treasured possession, is a prime prop included in these sessions. Often senior sessions will involve the subject's friends and favorite haunts. Or, in the case of

senior girls, they will want to be photographed in a fashion/glamour pose, wearing something pretty racy—like what they see on MTV. This is all part of the process of expressing their individuality and becoming an adult. Instead of resisting it, many smart photographers are now catering to it.

With these types of sessions, it is important to have a pre-shoot meet-

ing with one or both parents to determine what is expected.

□ RELAXED, NATURAL POSING

Adolescents and senior-age kids will react poorly to traditional posing, yet some structure is needed or you are no longer in the realm of portraiture. The best way to proceed is to attain a natural pose. With boys,

find a pose that they feel natural in and work out of that pose. Find a comfortable seat, even if it's on the floor of the studio, and then modify the pose to make it a professional portrait.

Girls, like women of all ages, want to be photographed at their best, looking slim and beautiful. Use poses that flatter her figure and that make her look attractive.

A good pose for teenage boys is to have them thrust their hands in their pockets with the thumbs out. It is a kind of "cool" pose in which they'll feel relaxed. Be sure to keep space between their arms and body. Another good posed for boys is to have them sit on the floor with one knee up and wrap their hands around the knee. It is a casual pose from which many variations can be achieved.

□ ACTIVE POSING

Seniors and teens like activity and bright colors in their portraits. They also like their music playing in the background as they pose, so ask them to bring along a few CDs when they come to have their portrait made. Work quickly to keep the energy level high.

Try to photograph several different settings with at least one outfit change. Show them the back-

Kids, more than anything else, want to be accepted for who they are, even though that is not necessarily established when they are in their teens. To get great teen portraits, one must accept that given. Here, a teen is photographed with his beautiful blue pick-up while wearing his favorite cap. He looks completely relaxed and at ease with who he is. Photograph by Tom Strade.

It's obvious that this senior is a soccer star—just look at her letter jacket, the ball and the air of self-confidence. Frank Frost created a number of similar images for her session and appears to have captured the essence of this young athlete.

grounds and props that you have available and ask them to choose among them. You should have a wide variety of backgrounds and props to choose from. You will be surprised at what they select.

□ PSYCHOLOGY

Part of your job is to make your subjects feel good about themselves, which can take the form of reassurance or flattery, both of which should be doled out in an appropriate way and in conservative doses or they won't be believed. It is often said that one of the ingredients of a great portrait photographer is an ability to relate to other people. With teens, a genuine interest in them as people can go a long way.

Part of being a good psychologist is watching the subject's mannerisms and expressions. You will get a chance to do that if you have a pre-session meeting, which is advisable. Take notes as to poses that the client may fall into naturally—both seated and standing poses. Get a feeling for how they carry themselves and their posture. You can then use this information in the photo session as you recall (from your notes) a certain pose they do quite naturally. Such insight makes them feel that you must know them or at least have noticed them in detail.

□ THE MANY FACES OF . . .

As with any good portrait sitting, the aim is to show the different sides of

LEFT: Monte Zucker shot this wonderful portrait outdoors under the cover of a porch. Daylight illuminated the left side of his face, his head turned slightly away from the light source to create the feeling of side-/back-lighting. A barebulb Quantum flash was used camera-right in order to wrap light around onto the right side of his face. Exposure was for the ambient light. The flash output was two f-stops less than the ambient light exposure. The edge of the shadow from the barebulb flash on his neck was softened in Photoshop. Catchlights were also diffused. Aside from the technical mastery of this image, the boy looks like a tennis player, perhaps one who just came off the court to have his portrait made. **FACING PAGE:** Relaxed posing can be attained in a number of ways. If the teen feels comfortable in the set that the photographer has arranged it will show. The posing and props for this portrait are a bit eclectic, yet this is a beautiful and successful senior portrait. The boy was photographed with a short lighting setup with a healthy 3.5:1 lighting ratio to add drama to the image. Photograph by Ira and Sandy Ellis.

the subject's personality. Adults have all sorts of armor and subterfuge that prevent people from seeing their true natures. Teenagers aren't nearly that sophisticated—but, like adults, they are multifaceted. Try to show their fun side as well as their serious side. If they are active or athletic, arrange to photograph them in the clothes worn for their particular sport or activity. Clothing changes help trigger the different

facets of personality, as do changes in location.

When you meet with the teen and his or her parents before the photo session, suggest that he or she bring along a variety of clothing changes. Include a formal outfit (like a tux or suit), a casual "kickin' back" outfit (shorts and a T-shirt), an outfit that is cool (one that they feel they look really great in) and an outfit that represents their main interest (a

baseball jersey and cap or a cheerleader's outfit).

You can also encourage kids to bring in their favorite items—or even a pet. This will help reveal their personalities even more and, like small children, the presence of their favorite things will help them feel relaxed and at home.

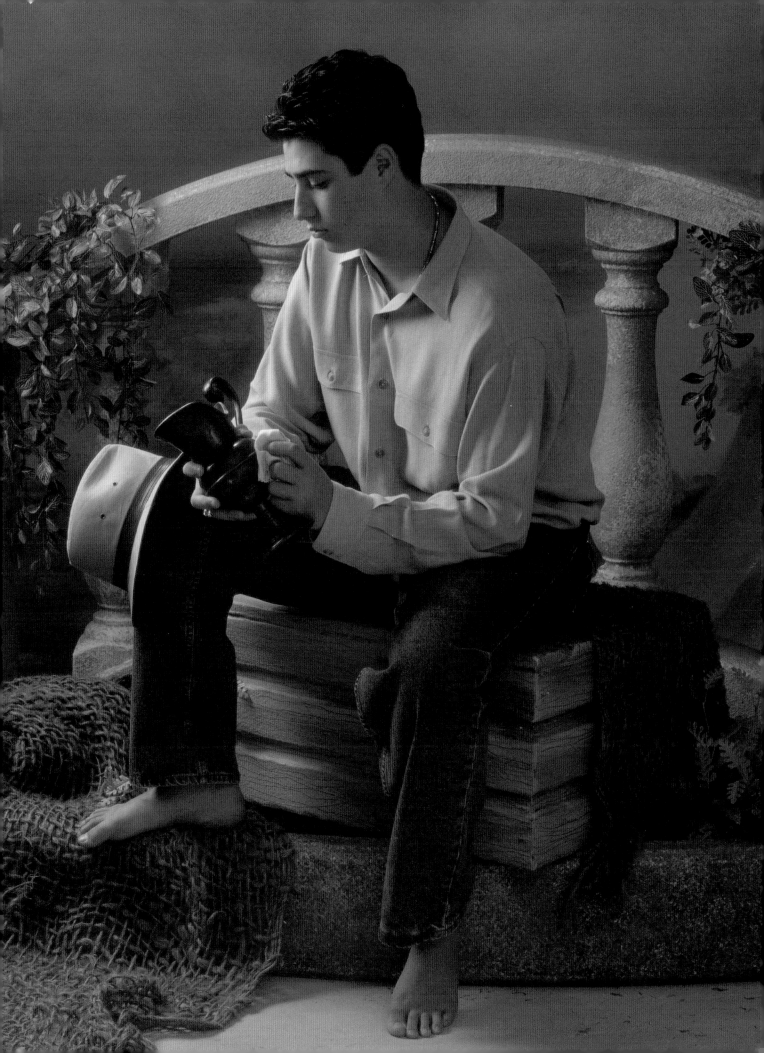

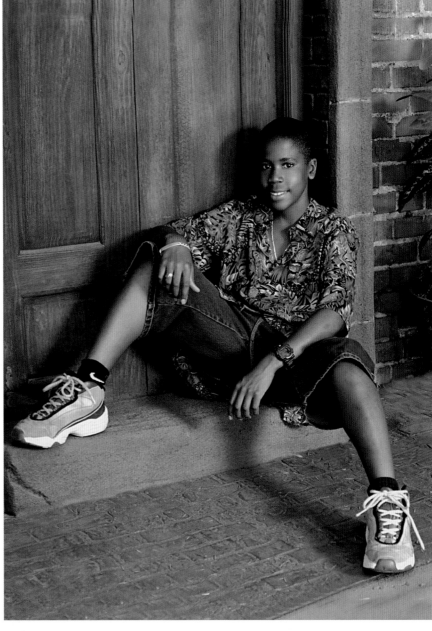

ABOVE: A high-school-age boy and his mom are unlikely subjects and yet in this wonderful image made by Don Emmerich both are rendered handsomely. Don stylized the image, blending image details such as the clothes, hair and background to give the image a charcoal effect. The image is upscale and very effective. RIGHT: A selection of outfits will ensure multiple print orders. In this outdoor portrait by Ira Ellis, the young man is pictured in one of his favorite outfits, which includes his favorite Nikes. The image was made in a faux doorway prop that Ira keeps out in the courtyard of his studio. The red brick background is actually the exterior of the studio.

□ HAIR AND MAKEUP

As anyone who has a child this age knows, hair and makeup (for girls) is a big part of their appearance. It is essential that the session encompass these areas. If you are not comfortable advising in these areas, have someone on hand who is and can either help or actually do the hair and makeup for the session. It will go a long way in making the teenager feel comfortable and relaxed. You don't necessarily have to have a hair and makeup artist at the shoot, but perhaps a young assistant who can be of help.

□ A STYLIZED, DIVERSE SELECTION

When a senior looks through the proofs, they will expect to see a variety of poses and looks, as well as some style and sensitivity in the images. They will probably like the images in which they look most like themselves, the ones that reveal their true natures. This could include either the casual poses or the formal ones. If you are smart, you will have a selection of in-studio images and outdoor portraits; a selection of the teen alone and a few with his or her session companions. And if the teen took the trouble to bring along some of their favorite things, be sure to make a selection of images that includes these items as well.

Storytelling Books

A recent development in children's portraiture is the creation of the story album, which is very similar to a bound wedding album. One such story album was put together by award-winning photographer Norman Phillips, who borrowed from the "day in the life" concept to create a photographic record of a special day in a life of a little boy named Barrett. The

album starts when Barrett wakes up and Norman follows him through a very average day, documenting everything. You would think the results would be mundane but, as you can see, the book is quite spectacular. Not only do the images reflect what it's like to live Barrett's life for a day, but it is a beautifully designed volume that will be a family heirloom for generations to come.

Here is Norman Phillips' concept of the story album: "The idea of 'a day in the life' had been in my head for some time. I considered producing it in a traditional bound album but it did not really fit my mental design. Then I saw the White Glove First Edition Books. This format was ideal for a creative presentation for a photographic essay. Next I needed to sell the idea to an appropriate client, one who could afford the fees. A child between two and a half and four was the perfect age, a busy little person. Barrett had been com-

Norman Phillips' album, *Day in the Life of Barrett*, documents a special day—and does it from start to finish.

You are loved...

Select pages from Norman Phillips' album, *Day in the Life of Barrett*.

ing to the studio since he was a baby and now he was three and it was the perfect time. For my first book I wanted a child with expression and personality. He also demonstrated a captivating independence. Barrett was the child for this project. The fact that he wore glasses added to the interest of the projected shots and the backgrounds behind the

story images. I suggested the book to his parents and they went for it. They have two copies of the book. Now Barrett has a little brother and his parents are planning a book for him too."

The design of the storybook came in part from the efforts of a team of former wedding photographers, Paul Thompson and Larry Crandall,

who comprise White Glove Albums, a company that became well known among wedding photographers for producing "library" bound albums.

Each book is custom made and has no inserts or glued-on pages. In fact, the photos are output directly onto the individual pages.

White Glove albums are painstakingly designed and published using QuarkXPress as the layout medium. Both Crandall and Thompson have input on the design and layout and offer suggestions and guidance as to composition, layout, graphics and color. Every tool is at White Glove's disposal, including drop shadows, edge effects, hand tinting, washes and just about every trick in the book available to a graphic designer. But the books are not gimmicky, they are elegant and impressive.

Not all storybooks need be as elaborate as the one just described. One can use a storytelling approach when a single image won't fully convey the moment or event. The book might consist of a series of images and perhaps poems or quotations, which can be hand-lettered or printed. Typical events that might inspire such an approach are a new pet, a

Select pages from Norman Phillips' album, Day in the Life of Barrett.

Children are a gift from God...

Children are a joy beyond measure...

Select pages from Norman Phillips' album, *Day in the Life of Barrett.*

new brother or sister, a special day (like a birthday or first haircut), a visit to grandma's and grandpa's house, and so on.

Pages 107–11 show outtakes from Norman Phillips' *Day in the Life of Barrett.* Norman had wanted to do such a project for a long time and is now planning to do more of these kinds of albums. This album

was an award winner at the 2001 WPPI album competition. One of the nicest things about this album is that the events are everyday events that will become priceless over time.

□ **PAGE DESIGN AND LAYOUT**

While design is a critical component of any well composed photograph,

good design is even more essential when laying out a book with multiple pages featuring photos, text and other visual elements. Look at any well designed book or glossy maga-zine and study the differences between the images on left and right-hand pages. They are decided-ly different but have one thing in common. They lead the eye toward the center of the book, commonly referred to as the "gutter." These photos use the same design elements photographers use in creating effec-tive images—lead-in lines, curves,

Select pages from Norman Phillips' album, *Day in the Life of Barrett.*

shapes and patterns. If a line or pattern forms a C shape, it is an ideal left-hand page, since it draws the eye into the gutter and across to the right-hand page. If an image is a backward C shape, it is an ideal right-hand page. Familiar shapes like hooks or loops, triangles or circles are used in the same manner to guide the eye into the center of the two-page spread and across to the right-hand page.

There is infinite variety in laying out images, text and graphic elements to create this left and right orientation. For example, an image or a series of photos can produce a strong diagonal line that leads from the lower left-hand corner of the left page to the gutter. That pattern can be duplicated on the right-hand page, or it can be contrasted for variety. The effect is visual motion—the eye follows the diagonal on the left to the vertical image on the right.

Even greater visual interest can be attained when a line or shape, which is started on the left-hand page, continues through the gutter, into the right-hand page and back again to the left-hand page. This is the height of visual movement in page design. Visual design should be playful and coax the eye to follow paths and signposts through the visuals on the pages.

When you lay out your book images, think in terms of variety of size. Some images should be small, some big. Some should extend across the spread. No matter how good the individual photographs

are, the effect of a book in which all the images are the same size is static.

Variety can be introduced by combining black & white and color, even on the same pages. Try combining detail shots and wide-angle panoramas. How about a series of close-up portraits of the child on the left-hand page contrasted with a wide-angle shot of the child's favorite pet, toy or even his bedroom? Do not settle for the one-picture-per-page theory. It's static and boring.

Learn as much as you can about the dynamics of page design. Think in terms of visual weight, not just size. Use symmetry and asymmetry, contrast and balance. Create visual tension by combining dissimilar elements. Don't be afraid to try different things. The more experience you get in laying out the images for the

book, the better you will get at presentation. Study Norman Phillips' story album presented here and you will see great creativity and variety in how images are combined and the infinite variety of effects that may be created.

Remember a simple concept: in Western civilization we read from left to right. We start on the left page and finish on the right. Good page design leads the eye from left to right and it does so differently on every page.

□ **A DAY IN THE LIFE . . .**
Michael and Pamela Ayers also call their family album program their "day in the life" program. The prices for complete services start at $1500, but most families spend from $3000 to $5000 to include albums for relatives (sometimes in smaller sizes),

Select pages from a family album created by Michael and Pamela Ayers.

Select pages from a family album created by Michael and Pamela Ayers.

Laura's first day of pre-first

second year of piano lessons

wall portraits and gift folios for relatives and friends.

The Ayerses do not provide this service at all on Saturdays, Sundays or holidays. Therefore, if the parents are employed out of the home, they must miss work for this very speical occasion! Everything is photographed digitally and the pair usually shoot from 600 to 800 images. The family picks their favorites and the Ayerses then design the album based on their choices.

The album is meant to reflect "one very special day" in the life of a family, so most of the images will be taken on just a single day in a period of four to six hours. Beforehand, Michael asks the family to think of all

ABOVE AND FACING PAGE: Select pages from a family album created by Michael and Pamela Ayers.

their favorite activities, such as horseback riding, swimming, skiing, barbecuing, picnicking, and even simple things like piggyback rides, playing with Legos™, swinging in the park, etc. The Ayerses literally become part of the family for this day! It's the perfect thing for all the world's photographers who want to give up working weekend weddings but don't want to give up the income.

The Ayerses are excited about their "day in the life" albums. Michael says, "We feel this will soon become our biggest profit center ever!"

Pages 112–15 show samples from the Ayerses' family album, the one that Michael produced to show as an example to prospective families. You will notice that the album is activity-centered and organized around certain activities or certain places within their home.

□ SEQUENCES

Sequences are an interesting way to portray the different sides of an event or special day, such as a first birthday party. Often sequences are shot rapid-fire with motor drives, documenting some small action. Sequences can also be a series of varied expressions taken from the same angle, depicting the many sides and moods of the child. These images are often displayed on mount boards or in folders and should follow the principles of good page design and layout.

Often sequences will be appropriate when a single photograph just doesn't convey the many wonderful things that might happen in a photo session. If story albums are a novel, then a sequence is more like a short story. A sequence or series should have the same rhythm and flow of a professionally designed page. In other words, you should be able to trace line, form, direction, movement, tension and balance within the assembled images. The viewer should be guided through the sequence in some logical fashion.

Glossary

Angle of incidence—The angle of incidence is the original axis on which light travels. The angle of reflection is the secondary angle light takes when reflected off of some surface. The angle of incidence is equal to the angle of reflection.

Balance—A state of visual symmetry among elements in a photograph.

Barebulb flash—A portable flash unit with a vertical flash tube that fires the flash illumination 360 degrees.

Barn doors—Black, metal folding doors that attach to a light's reflector; used to control the width of the beam of light.

Bleed—A page in a book or album in which the photograph extends to the edges of the page.

Bounce flash—Bouncing the light of a studio or portable flash off a surface such as a ceiling or wall to produce indirect, shadowless lighting.

Box light—A diffused light source housed in a box-shaped reflector. The bottom of the box is translucent material; the side pieces of the box are opaque, but they are coated with a reflective material such as foil on the inside to optimize light output.

Broad lighting—One of two basic types of portrait lighting in which the key light illuminates the side of the subject's face turned toward the camera.

Butterfly lighting—One of the basic portrait lighting patterns, characterized by a high-key light placed directly in line with the line of the subject's nose. This lighting produces a butterfly-like shadow under the nose. Also called paramount lighting.

Catchlight—The specular highlights that appear in the iris or pupil of the subject's eyes reflected from the portrait lights.

CC filters—Color compensating filters that come in gel or glass form and are used to correct the color balance of a scene.

Color temperature—The temperature (in degrees Kelvin) of a light source or film sensitivity. Color films are balanced for 5500°K (daylight), 3200°K (tungsten) or 3400°K (photoflood).

Cross-lighting—Lighting that comes from the side of the subject, skimming facial surfaces to reveal the maximum texture in the skin. Also called sidelighting.

Cross shadows—Shadows created by lighting a group with two light sources from either side of the camera. These should be eliminated to restore the "one-light" look.

Depth of field—The distance that is sharp beyond and in front of the focus point at a given f-stop.

Depth of focus—The amount of sharpness that extends in front of and behind the focus point. Some lens's depth of focus extends 50 percent in front of and 50 percent behind the focus point. Other lenses may vary.

Diffusion flat—A portable, translucent diffuser that can be positioned in a window frame or near the subject to diffuse the light striking him or her.

Double truck—Two bleed pages, a left and right combined. Usually a panoramic or long horizontal image is used to "bleed" across the two pages.

Dragging the shutter—Using a shutter speed slower than the X-sync speed in order to capture the ambient light in a scene.

E.I.—Otherwise known as exposure index. The term refers to a film speed other than the rated ISO of the film.

Feathering—Misdirecting the light deliberately so that the edge of the beam of light illuminates the subject.

Fill card—A white or silver-foil-covered card used to reflect light back into the shadow areas of the subject.

Fill light—Secondary light source used to fill-in the shadows created by the key light.

Flash-fill—Flash technique that uses electronic flash to fill-in the shadows created by the main light source.

Flashing—A technique used in printing to darken an area of the print by exposing it to raw light.

Flash key—Flash technique in which the flash becomes the main light source and the ambient light in the scene fills the shadows created by the flash.

Flashmeter—A handheld incident meter that measures both the ambient

light of a scene and when connected to the main flash, will read flash only or a combination of flash and ambient light. They are invaluable for determining outdoor flash exposures and lighting ratios.

Focusing an umbrella—Adjusting the length of exposed shaft of an umbrella in a light housing to optimize light output.

Foreshortening—A distortion of normal perspective caused by close proximity of the camera/lens to the subject. Foreshortening exaggerates subject features—noses appear elongated, chins jut out and the backs of heads may appear smaller than normal.

45-degree lighting—Portrait lighting pattern characterized by a triangular highlight on the shadow side of the face. Also called Rembrandt lighting.

Full-length portrait—A pose that includes the full figure of the model. Full-length portraits can show the subject standing, seated or reclining.

Gobo—Light-blocking card that is supported on a stand or boom and positioned between the light source and subject to selectively block light from portions of the scene.

Gutter—The inside center of a book or album.

Head-and-shoulder axis—Imaginary lines running through shoulders (shoulder axis) and down the ridge of the nose (head axis). Head and shoulder axes should never be perpendicular to the line of the lens axis.

High key lighting—Type of lighting characterized by low lighting ratio and a predominance of light tones.

Highlight—An area of the scene on which direct light is falling, making it brighter than areas not receiving direct light; i.e., shadows.

Highlight brilliance—The specularity of highlights on the skin. A negative with good highlight brilliance shows specular highlights (paper base white) within a major highlight area.

Achieved through good lighting and exposure techniques.

Hot spots—A highlight area of the negative that is overexposed and is without detail. Sometimes these areas are etched down to a printable density.

Incident light meter—A handheld light meter that measures the amount of light falling on its light-sensitive cell.

Key light—The main light in portraiture used to establish the lighting pattern and define the facial features of the subject.

Kicker—A backlight (a light coming from behind the subject) that highlights the hair, side of the face or contour of the body.

Lead-in line—In compositions, a pleasing line in the scene that leads the viewer's eye toward the main subject.

Lighting ratio—The difference in intensity between the highlight side of the face and the shadow side of the face. A 3:1 ratio implies that the highlight side is three times brighter than the shadow side of the face.

Loop lighting—A portrait lighting pattern characterized by a loop-like shadow on the shadow side of the subject's face. Differs from paramount or butterfly lighting because the main light is slightly lower and farther to the side of the subject.

Low key lighting—Type of lighting characterized by a high lighting ratio and strong scene contrast as well as a predominance of dark tones.

Main light—Synonymous with key light.

Matte box—A front-lens accessory with retractable bellows that holds filters, masks and vignettes for modifying the image.

Mirror slap—Vibration caused by the camera's TTL mirror moving out of the way and returning to its normal position at the instant of exposure.

Modeling light—A secondary light mounted in the center of a studio flash

head that gives a close approximation of the lighting that the flash tube will produce. Usually high intensity, low-heat output quartz bulbs.

Overlighting—When the main light is either too close to the subject, or too intense and oversaturates the skin with light, making it impossible to record detail in highlighted areas. Best corrected by feathering the light or moving it back.

Parabolic reflector—Oval-shaped dish that houses a light and directs its beam outward in an even, controlled manner.

Paramount lighting—One of the basic portrait lighting patterns, characterized by a high key light placed directly in line with the line of the subject's nose. This lighting produces a butterfly-like shadow under the nose. Also called butterfly lighting.

Perspective—The appearance of objects in a scene as determined by their relative distance and position.

Push-processing—Extended development of film, sometimes in a special developer, that increases the effective speed of the film.

Reflected light meter—Measures the amount of light reflected from a surface or scene. All in-camera meters are of the reflected type.

Reflector—(1) Same as fill card. (2) A housing on a light that reflects the light outward in a controlled beam.

Rembrandt lighting—Same as 45-degree lighting.

Rim lighting—Portrait lighting pattern where the key light is behind the subject and illuminates the edge of the subject. Most often used with profile poses.

Rule of thirds—Format for composition that divides the image area into thirds, horizontally and vertically. The intersection of two lines is a dynamic point where the subject should be placed for the most visual impact.

Scrim—A panel used to diffuse sunlight. Scrims can be mounted in panels and set in windows, used on stands or can be suspended in front of a light source to diffuse the light.

Seven-eighths view—Facial pose that shows approximately seven-eighths of the face. Almost a full-face view as seen from the camera.

Shadow—An area of the scene on which no direct light is falling, making it darker than areas receiving direct light, i.e., highlights.

Short lighting—One of two basic types of portrait lighting in which the key light illuminates the side of the face turned away from the camera.

Slave—A remote triggering device used to fire auxiliary flash units. These may be optical or radio-controlled.

Softbox—Same as a box light. Can contain one or more light heads and single or double-diffused scrims.

Soft-focus lens—Special lens that uses spherical or chromatic aberration in its design to diffuse the image points.

Specular highlights—Sharp, dense image points on the negative. Specular highlights are very small and usually appear on pores in the skin.

Split lighting—Type of portrait lighting that splits the face into two distinct areas: shadow side and highlight side. The key light is placed far to the side of the subject and slightly higher than the subject's head height.

Spotmeter—A handheld reflected light meter that measures a narrow angle of view, usually 1–4 degrees.

Straight flash—The light of an on-camera flash unit that is used without diffusion, i.e., straight.

Subtractive fill-in—Lighting technique that uses a black card to subtract light from a subject area in order to create a better defined lighting ratio. Also refers to the placement of a black card over the subject in outdoor portraiture to make the light more frontal and less overhead.

TTL-balanced fill-flash—Flash exposure systems that read the flash exposure through the camera lens and adjust flash output to compensate for flash and ambient light exposures, producing a balanced exposure.

Tension—A state of visual imbalance within a photograph.

Three-quarter–length pose—Pose that includes all but the lower portion of the subject's anatomy. Can be from above the knees and up, or below the knees and up.

Three-quarter view—Facial pose that allows the camera to see three-quarters of the facial area. Subject's face usually turned 45 degrees away from the lens so that the far ear disappears from camera view.

Umbrella lighting—Type of soft, casual lighting that uses one or more photographic umbrellas to diffuse the light source(s).

Vignette—A semicircular, soft-edged border around the main subject. Vignettes can be either light or dark in tone and can be included at the time of shooting, or added later in printing.

Wraparound lighting—Soft type of light, produced by umbrellas, that wraps around subject producing a low lighting ratio and open, well-illuminated highlight areas.

X-sync—The shutter speed at which focal-plane shutters synchronize with electronic flash.

Zebra—A term used to describe reflectors or umbrellas having alternating reflective materials such as silver and white cloth.

The Photographers

Michael J. Ayers *(PPA-Certified, M.Photog.,Cr., APM, AOPA, AEPA, AHPA)*. WPPI's 1997 International Portrait Photographer of the Year, Michael Ayers is a studio owner from Lima, Ohio. He has lectured to photographers about weddings, portraiture and album design all across North America and has been a featured speaker in Europe. Michael and his wife, Pam, are considered among the best wedding album designers in the world. Their creations and constructions have been honored as numerous Master's Loan Collection albums and they have received honors in the WPPI Awards of Excellence print and album competitions.

David and Susan Bentley. David Bentley owns and operates Bentley Studio, Ltd. in Frontenac, Missouri, with his wife, Susan, who is also a master photographer. With a background in engineering, David calls upon a systematic as well as creative approach to each of his assignments. His thirty years of experience and numerous awards speak to the success of the system. David and Susan specialize in wedding photography and portraiture, especially children's portraits.

Bambi Cantrell. Bambi is a decorated photographer from the San Francisco Bay area. She is well known for her creative photojournalistic style and is the recent coauthor of a best-selling book on wedding photography, entitled *The Art of Wedding Photography* (Amphoto). Her images have appeared in *Martha Stewart Living, The Professional Photographer, American Photo, Time* and *Ebony,* just to name a few. She is one of the country's most sought-after workshop instructors with sponsors including Eastman Kodak, Hasselblad USA, Canon USA and Art Leather Manufacturing.

Anthony Cava *(BA, MPA, APPO).* Born and raised in Ottawa, Ontario, Canada, Anthony Cava owns and operates Photolux Studio with his brother, Frank. Frank and Anthony's parents originally founded Photolux as a Wedding/Portrait Studio, thirty years ago. Anthony joined WPPI and the Professional Photographers of Canada ten years ago. He was the youngest "Master of Photographic Arts" (MPA) in Canada. One of his major accomplishments is that he won WPPI's Grand Award with the first print he ever entered in competition.

Gigi Clark. With four college degrees, Gigi Clark has a varied background including multimedia, instructional design, graphic design and conceptual art. She brings all of her multidisciplined talents to her upscale photography business located in Southern California. She has received numerous awards and honors including several first places in both PPA and WPPI competitions, as well as the first-time offered Fujifilm Award for "Setting New Trends."

Jerry D. Jerry D owns and operates Enchanted Memories, a successful portrait and wedding studio in Upland, California. Jerry has had several careers in his lifetime, from licensed cosmetologist to black belt martial arts instructor. Jerry is a highly decorated photographer by WPPI and has achieved many national awards since joining the organization.

Ira and Sandy Ellis. This team of photographers owns and operates Ellis Portrait Design in Moorpark, California. The Ellis team, in addition to twenty or so weddings a year, produces children's fantasy portraits, a type of high-end image created around an imaginative concept.

Both Ira and Sandy have been honored in national print competitions at PPA and WPPI and had their photography featured in national ad campaigns.

Don Emmerich *(M.Photog., M.Artist, M.EI, Cr., CEI, CPPS).* Don Emmerich is a virtuoso of the visual arts and one of the pioneers of applied photographic digital imaging. He belongs to a select group of professionals who have earned all four photographic degrees, and was chosen to be a member of the exclusive Camera Craftsmen of America society that is comprised of the top-forty portrait photographers in the United States. Don has been PPA's technical editor for the past twelve years, with some 150 articles published in various magazines, nationally and internationally.

Gary Fagan *(M.Photog.,Cr., CPP).* Gary, along with his wife, Jan, owns and operates an in-home studio in Dubuque, Iowa. Gary concentrates primarily on families and high-school seniors, using his half-acre outdoor studio as the main setting. At the 2001 WPPI convention, Gary was awarded WPPI's Accolade of Lifetime Excellence. He was also awarded the International Portrait of the Year by that same organization. At the Heart of America convention, he had the Top Master Print and the Best of Show. For the highest master print in the region, Gary received the Regional Gold Medallion award at the PPA National convention ASP banquet.

Rick Ferro *(Certified Professional Photographer).* Rick Ferro has served as senior wedding photographer at Walt Disney World. In his twenty years of photography experience, he has photographed over 10,000 weddings. He has received numerous awards, including having prints accepted into PPA's Permanent Loan Collection. He has won numerous awards from WPPI and is the author of *Wedding Photography: Creative Techniques for Lighting and Posing*, published by Amherst Media.

Frank A. Frost, Jr. *(PPA Certified, M.Photog.,Cr., APM, AOPA, AEPA, AHPA).* Located in the heart of the Southwest, Frank Frost has been creating his own classic portraiture in Albuquerque, New Mexico for over eighteen years. Believing that "success is in the details," Frank pursues both the artistry and business of photography with remarkable results, which have earned him numerous awards from WPPI and PPA along the way. His photographic ability stems from an instinctive flair for posing, composition and lighting.

Kelly Greer. Kelly Greer, of Lexington, Kentucky, co-owns The Gallery studio with her mother, Winnie Greer. Her younger sister, Leeann, a graduate of Brooks Institute of Photography, recently joined the staff. Kelly has won awards for album design, which she markets as European art books. Kelly specializes in engagement portraits and weddings. Winnie is a portrait photographer, specializing in children, families and seniors.

Dale P. Hansen *(PPA Certified, APM, AOPA).* Dale Hansen holds a BA degree from Brooks Institute of Photography in Santa Barbara, California and has had many of his photographs published nationally, in such publications as *Audubon, National Geographic, World Book* and the cover of *PPA Storyteller* in March 1999.

Jeff Hawkins. Jeff and his wife, Kathleen, operate a fully digital high-end wedding and portrait photography studio in Orlando, Florida. As a team, they have authored *Professional Marketing & Selling Techniques for Wedding Photographers* and *Professional Techniques for Digital Wedding Photography* both published by Amherst Media. Jeff Hawkins has been a professional photographer for over twenty years. Kathleen Hawkins holds a Masters in Business Administration and served as past president of the Wedding Professionals of Central Florida (WPCF) and past affiliate vice president for the National Association of Catering Executives (NACE).

Travis Hill. Travis Hill is the son of Barbara Fender Rice and Patrick Rice. Although only a teenager, he has won awards from both WPPI and PPA and was named the Photographer of the Year by the Society of Northern Ohio Professional Photographers.

Tim Kelly. *(M.Photog.).* Tim Kelly is an award-winning photographer and the owner of an highly-awarded color lab. Since 1988, he has developed educational programs and delivered them to professional por-

trait photographers worldwide. Tim was named Florida's Portrait Photographer of the Year in 2001 and has earned numerous Kodak Awards of Excellence and Gallery Awards. Several of his images have been featured in the PPA Loan Collection. His studio/gallery in Lake Mary, FL, is devoted to fine art portraiture and hand-crafted signature work.

Phil Kramer. In 1989, after graduating from the Antonelli Institute of Art and Photography, Phil Kramer opened his own studio, Phil Kramer Photographers, specializing in fashion, commercial and wedding photography. Today, Phil's studio is one of the most successful in the Philadelphia area and has been recognized by editors as one of the top wedding studios in the country. Recently, he opened offices in Princeton, New Jersey, New York City, Washington, D.C. and West Palm Beach, Florida. An award-winning photographer, Phil's images have appeared in numerous magazines and books both here and abroad. He is often a featured speaker on the professional photographer's lecture circuit.

Robert Lino (*M.Photog.,Cr., PPA Cert., APM, AOPM, AEPA, FDPE, FSA*). Robert Lino of Miami, Florida specializes in fine portraiture and social events. His style is formal and elegant; he particularly excels in posing and his ability to capture feeling and emotion in every image. Lino is a highly decorated photographer in national print competitions and is a regular on the workshop and seminar circuit.

Frances Litman. Frances Litman is an internationally known, award-winning photographer who resides in Victoria, British Columbia. She has been featured by Kodak Canada in national publications and has had her images published in numerous books, magazine covers and in Fujifilm advertising campaigns. She was awarded a Craftsman and Masters from the Professional Photographers Association of Canada. She has been awarded the prestigious Kodak Gallery Award and has also been awarded the Photographer of the Year award by the Professional Photographers Association of British Columbia.

Robert Love (*APM, AOPA, AEPA, M.Photog., Cr., CPP*) and **Suzanne Love** (*Cr. Photog.*). Robert Love is a member of Cameracraftsmen of America, one of forty active members in the world. He and his wife, Suzanne, create all of their images on location. Preferring the early evening "love light," they have claimed the outdoors as their "studio." This gives their images a feeling of romance and tranquillity.

Rita Loy. Rita Loy is the co-owner of Designing Portrait Images, along with her husband, Doug Loy, in Spartanburg, South Carolina. Rita has been repeatedly honored by PPA and SCPP, being named "Photographer of the Year" five times by the South Carolina Professional Photographers Association. She has also received thirteen Kodak Gallery Awards of Photographic Excellence and is a member of the Kodak Pro Team program. Her husband, Doug, holds a Photographic Craftsman Degree from PPA and serves as the current president of South Carolina Professional Photographers.

Tammy Loya. Tammy Loya is an award-winning children's portrait specialist from Ballston-Spa, NY. In her first WPPI Awards of Excellence print competition last year, she won a first and second place in the "children" category. All her other entries each received honorable mentions. Her studio is a converted barn, which includes a Victorian theater for previewing her client's images known as the Jail House Rock Theater.

Heidi Mauracher (*M.Photog.,Cr., CPP, FBIPP, AOPA, AEPA*). To date, Heidi Mauracher has presented programs before audiences around the world. She has taught at several affiliated schools as well as the PPA's Winona School of Professional Photography. Her articles and photographic images have been featured in a variety of professional magazines and books, and her unique style has won her many PPA Loan Collection prints and more than one photograph that has scored a perfect "100" in international competition.

William S. McIntosh (*M.Photog., Cr., F-ASP*). Bill McIntosh photographs executives and their families all over the U.S. and travels to England frequently on special assignments. He has lectured all over the world. His popular book, *Location Portraiture: The Story Behind the Art* (Tiffen Company LLC, 1996), is sold in bookstores and other outlets.

Ferdinand Neubauer *(PPA Cert., M.Photog.,Cr., APM).* Ferdinand Neubauer started photographing weddings and portraits over thirty years ago. He has won many awards for photography on state, regional and international levels. He is also the author of *The Art of Wedding Photography* and *Adventures in Infrared* (both self-published). His work has appeared in numerous national publications and he has been a speaker at various photographic conventions and events.

Norman Phillips *(AOPA).* Norman Phillips has been awarded the WPPI Accolade of Outstanding Photographic Achievement (AOPA), is a registered Master Photographer with Britain's Master Photographers Association, is a Fellow of the Society of Wedding & Portrait Photographers and is a Technical Fellow of Chicagoland Professional Photographers Association. He is a frequent contributor to photographic publications, a print judge and a guest speaker at seminars and workshops across the country. He is also the author of *Lighting Techniques for High Key Portrait Photography*, published by Amherst Media.

Stephen Pugh. Stephen Pugh is an award-winning wedding photographer from Great Britain. He is a competing member of both WPPI and the British Guild and has won numerous awards in international print competitions.

Barbara Rice *(Cr.Photog., PFA, APM).* Barbara Rice has been a professional photographer for twenty-two years working in Pennsylvania, New York and Ohio. An accomplished photographic artisan, Barbara has received top honors in several photographic competitions.

Kimarie Richardson. Kimarie Richardson owns and operates Fantasy Stills by Kimarie in Ukiah, California. She is a professionally trained makeup artist and a self-taught photographer, who made the transition to full-time photography ten years ago. She is well known in the Northern California area, and more recently nationally, for her hand-painted "Angel Baby" portraits, children's portraits, and '40s-style Hollywood glamour photographs. Two years ago she entered an international print competition for the first time and won a Grand Award for her print, *Angelica's Light.*

Brian and Judith Shindle. Brian and Judith Shindle own and operate Creative Moments in Westerville, Ohio. This studio is home to three enterprises under one umbrella: a working photography studio, an art gallery and a full-blown event planning business. Brian's work has received numerous awards from WPPI in international competition.

Tom Strade. Tom Strade owns and operates two studios in Bethany and Hamilton, Missouri, specializing in portraiture of children, seniors, couples and families. Tom has been honored by numerous professional organizations, including being awarded a Fellow of Photography degree by the Professional Photographers Association of Missouri. He has also been honored nationally by the PPA.

David Anthony Williams *(M.Photog., FRPS).* David Anthony Williams owns and operates a wedding studio in Ashburton, Victoria, Australia. In 1992 he achieved the rare distinction of Associateship and Fellowship of the Royal Photographic Society of Great Britain (FRPS) on the same day. Through the annual Australian Professional Photography Awards system, Williams achieved the level of Master of Photography with Gold Bar—the equivalent of a double master. In 2000, he was awarded the Accolade of Outstanding Photographic Achievement from WPPI, and has been a Grand Award winner at their annual conventions in both 1997 and 2000.

Monte Zucker. When it comes to perfection in posing and lighting, timeless imagery and contemporary, yet classical photographs, Monte Zucker is world-famous. He's been bestowed every major honor the photographic profession can offer, including WPPI's Lifetime Achievement Award. In his endeavor to educate photographers at the highest level, Monte, along with partner Gary Bernstein, has created the information-based web site for photographers, Zuga.net.

Index

Other Books from
Amherst Media

Also by Bill Hurter . . .

PORTRAIT PHOTOGRAPHER'S HANDBOOK

Bill Hurter has compiled a step-by-step guide to portraiture that easily leads the reader through all phases of portrait photography. This book will be an asset to experienced photographers and beginners alike. $29.95 list, 8½x11, 128p, full color, 60 photos, order no. 1708.

THE BEST OF WEDDING PHOTOGRAPHY

Learn how the top wedding photographers in the industry transform special moments into lasting romantic treasures with the posing, lighting, album design and customer service pointers found in this book. $29.95 list, 8½x11, 128p, 150 full-color photos, order no. 1747.

GROUP PORTRAIT PHOTOGRAPHER'S HANDBOOK

Featuring images by over twenty of the industry's top portrait photographers, this indispensible book offers timeless tips for composing, lighting and posing outstanding group portraits. $29.95 list, 8½x11, 128p, 120 full-color photos, order no. 1740.

Lighting for People Photography, 2nd Ed.
Stephen Crain

The up-to-date guide to lighting. Includes: setups, equipment information, strobe and natural lighting, and much more! Features diagrams, illustrations, and exercises for practicing the techniques discussed in each chapter. $29.95 list, 8½x11, 120p, 80 b&w and color photos, glossary, index, order no. 1296.

Outdoor and Location Portrait Photography 2nd Edition
Jeff Smith

Learn how to work with natural light, select locations, and make clients look their best. Step-by-step discussions and helpful illustrations teach you the techniques you need to shoot outdoor portraits like a pro! $29.95 list, 8½x11, 128p, 60+ full-color photos, index, order no. 1632.

Wedding Photography: CREATIVE TECHNIQUES FOR LIGHTING AND POSING, 2nd Edition
Rick Ferro

Creative techniques for lighting and posing wedding portraits that will set your work apart from the competition. Covers every phase of wedding photography. $29.95 list, 8½x11, 128p, full-color photos, index, order no. 1649.

Black & White Portrait Photography
Helen T. Boursier

Make money with b&w portrait photography. Learn from top b&w shooters! Studio and location techniques, with tips on preparing your subjects, selecting settings and wardrobe, lab techniques, and more! $29.95 list, 8½x11, 128p, 130+ photos, index, order no. 1626.

Profitable Portrait Photography
Roger Berg

A step-by-step guide to making money in portrait photography. Combines information on portrait photography with detailed business plans to form a comprehensive manual for starting or improving your business. $29.95 list, 8½x11, 104p, 100 photos, index, order no. 1570.

Professional Secrets for Photographing Children
2nd Ed.

Douglas Allen Box

Covers every aspect of photographing children on location and in the studio. Prepare children and parents for the shoot, select the right clothes, capture a child's personality, and shoot storybook themes. $29.95 list, 8½x11, 128p, 80 full-color photos, index, order no. 1635.

Family Portrait Photography

Helen Boursier

Learn how to operate a successful portrait studio. Includes: marketing family portraits, advertising, working with clients, posing, lighting, and selection of equipment. Includes images from a variety of top portrait shooters. $29.95 list, 8½x11, 120p, 123 photos, index, order no. 1629.

Wedding Photojournalism

Andy Marcus

Create dramatic unposed wedding portraits. From start to finish you'll learn where to be, what to look for and how to capture it on film. A hot technique for contemporary wedding albums! $29.95 list, 8½x11, 128p, b&w, over 50 photos, order no. 1656.

Studio Portrait Photography of Children and Babies, 2nd Ed.

Marilyn Sholin

Work with the youngest portrait clients to create images that will be treasured for years. Includes tips for working with kids from infant to preschooler. Features: lighting, posing and more! $29.95 list, 8½x11, 128p, 90 full-color photos, order no. 1657.

Photo Retouching with Adobe® Photoshop®
2nd Edition

Gwen Lute

Teaches every phase of the process, from scanning to output. Learn to restore damaged photos, correct imperfections, create composite images and more. $29.95 list, 8½x11, 120p, 60+ photos, order no. 1660.

Storytelling Wedding Photography

Barbara Box

Barbara and her husband shoot as a team at weddings. Here, she shows you how to create outstanding candids, and combine them with formal portraits to create a unique wedding album. $29.95 list, 8½x11, 128p, 60 b&w photos, order no. 1667.

Fine Art Children's Photography

Doris Carol Doyle and Ian Doyle

Learn to create fine art portraits of children in black & white. Includes: posing, lighting for studio portraits, shooting on location, clothing selection, working with kids, and more! $29.95 list, 8½x11, 128p, 60 photos, order no. 1668.

Marketing and Selling Black & White Portrait Photography

Helen T. Boursier

A complete manual for adding b&w portraits to the products you offer clients (or offering exclusively b&w photography). Learn how to attract clients and deliver the portraits that will keep them coming back. $29.95 list, 8½x11, 128p, 50+ photos, order no. 1677.

Photographing Children in Black & White

Helen T. Boursier

Learn the techniques professionals use to capture classic portraits of children (of all ages) in black & white. Discover posing, shooting, lighting and marketing techniques for black & white portraiture in the studio or on location. $29.95 list, 8½x11, 128p, 100 photos, order no. 1676.

Posing and Lighting Techniques for Studio Photographers

J. J. Allen

Master the skills you need to create beautiful lighting for portraits of any subject. Posing techniques for flattering, classic images help turn every portrait into a work of art. $29.95 list, 8½x11, 120p, 125 full-color photos, order no. 1697.

Corrective Lighting and Posing Techniques for Portrait Photographers

Jeff Smith

Learn to make every client look his or her best by using lighting and posing to conceal real or imagined flaws—from baldness, to acne, to figure flaws. $29.95 list, 8½x11, 120p, 150 full-color photos, order no. 1711.

Professional Secrets of Natural Light Portrait Photography

Douglas Allen Box

Learn to utilize natural light to create inexpensive and hassle-free portraiture. Beautifully illustrated with detailed instructions on equipment, setting selection and posing. $29.95 list, 8½x11, 128p, 80 full-color photos, order no. 1706.

Traditional Photographic Effects with Adobe Photoshop

Michelle Perkins and Paul Grant

Use Photoshop to enhance your photos with handcoloring, vignettes, soft focus and much more. Every technique contains step-by-step instructions for easy learning. $29.95 list, 8½x11, 128p, 150 photos, order no. 1721.

Master Posing Guide for Portrait Photographers

J. D. Wacker

Learn the techniques you need to pose single portrait subjects, couples and groups for studio or location portraits. Includes techniques for photographing weddings, teams, children, special events and much more. $29.95 list, 8½x11, 128p, 80 photos, order no. 1722.

High Impact Portrait Photography

Lori Brystan

Learn how to create the high-end, fashion-inspired portraits your clients will love. Features posing, alternative processing and much more. $29.95 list, 8½x11, 128p, 60 full-color photos, order no. 1725.

Beginner's Guide to Adobe® Photoshop®

Michelle Perkins

Learn the skills you need make your images look their best, create original artwork or add unique effects. All topics are presented in short, easy-to-digest sections that will boost confidence and ensure outstanding images. $29.95 list, 8½x11, 128p, 150 full-color photos, order no. 1732.

Professional Techniques for Digital Wedding Photography

Jeff Hawkins and Kathleen Hawkins

From selecting the right equipment to building an efficient digital workflow, this book teaches how to best make digital tools and marketing techniques work for you. $29.95 list, 8½x11, 128p, 80 full-color photos, order no. 1735.

Lighting Techniques for High Key Portrait Photography

Norman Phillips

From studio to location shots, this book shows readers how to meet the challenges of high key portrait photography to produce images their clients will adore. $29.95 list, 8½x11, 128p, 100 full-color photos, order no. 1736.

The Art and Business of High School Senior Portrait Photography

Ellie Vayo

Learn the techniques that have made Ellie Vayo's studio one of the most profitable senior portrait businesses in the United States. Covers advertising design, customer service skills, clothing selection, and more. $29.95 list, 8½x11, 128p, 100 full-color photos, order no. 1743.

Photographing Children with Special Needs

Karen Dórame

Explains the symptoms of spina bifida, autism, cerebral palsy and more, teaching photographers how to safely and effectively capture the unique personalities of special-needs children. $29.95 list, 8½x11, 128p, 100 full-color photos, order no. 1749.

More Photo Books Are Available

Contact us for a FREE catalog:
AMHERST MEDIA
PO BOX 586
AMHERST, NY 14226 USA

www.AmherstMedia.com

Ordering & Sales Information:

INDIVIDUALS: If possible, purchase books from an Amherst Media retailer. Write to us for the dealer nearest you. To order direct, send a check or money order with a note listing the books you want and your shipping address. For domestic and international shipping rates, please visit our website or contact us at the numbers listed below. Visa and MasterCard accepted. New York State residents add 8% sales tax.

DEALERS, DISTRIBUTORS & COLLEGES: Write, call or fax to place orders. For price information, contact Amherst Media or an Amherst Media sales representative. Net 30 days.

1(800)622-3278 or (716)874-4450
FAX: (716)874-4508

All prices, publication dates, and specifications are subject to change without notice.
Prices are in U.S. dollars. Payment in U.S. funds only.